COMIC ARTISTS-ASIA

Manga Manhwa Manhua

COMIC ARTISTS-ASIA

Manga Manhwa Manhua

Copyright ©2004 by HARPER DESIGN INTERNATIONAL

First published in 2004 by:
Harper Design International,
An imprint of HarperCollins*Publishers*
10 East 53rd Street
New York, NY 10022
Tel: (212) 207-7000
Fax: (212) 207-7654
HarperDesign@harpercollins.com
www.harpercollins.com

Distributed throughout the world by:
HarperCollins International
10 East 53rd Street
New York, NY 10022
Fax: (212) 207-7654

HarperCollins books may be purchased for educational, business, or sales promotional use. For information, please write: Special Markets Department, HarperCollins Publishers Inc., 10 East 53rd Street, New York, NY 10022.

Design: yo-yo Suzuki (yo-yo rarandays)
Text & editing: Rika Sugiyama (Style. Co., Ltd.)
English translation: JEX Limited (Linda Yabushita)
Coordination: Mick Fujita, Noriko Sakai

Library of Congress Control Number: 2004104184

ISBN 0-06-058924-8

Printed in China
First Printing, 2004

COMIC ARTISTS-ASIA
Manga Manhwa Manhua

Rika Sugiyama

HDi
HARPER
DESIGN
international

An Imprint of Harper Collins *Publishers*

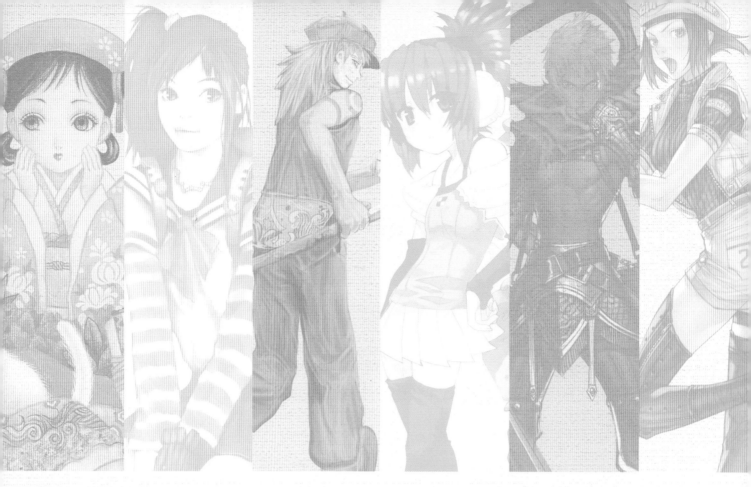

Contents

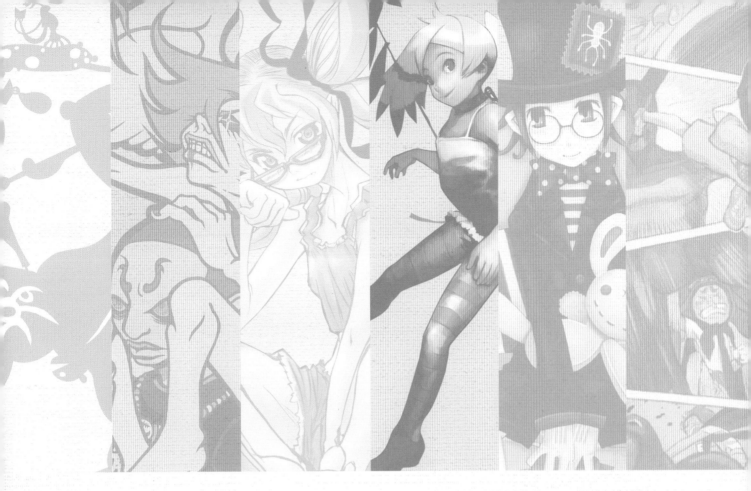

Introduction

It is no surprise that Japan is home to many artists who specialize in manga (Japanese cartoon and comic art), because manga has been an increasingly dominant force in Japan's entertainment industry. In recent years, as this expressive form has become even more firmly entrenched in the popular culture, it has given rise to a major new genre—manga character art. Manga character artists are influenced not only by their love of manga, anime, and video games, but also by their penchant for drawing, painting, and comic book illustration. They have developed distinctive, individual styles that incorporate the techniques and essences of all of these art forms. This volume introduces a sampling of some of the best young artists whose intriguing manga character art appears in a variety of genres and mediums.

But Japan no longer has the monopoly on manga. In Korea, the popularization of the Internet, collaborations with Japan's video game and anime industries, and the rapid growth of Korea's own manga, anime, and video game industries have fostered a number of young manga character artists who are just as talented as their Japanese counterparts. This collection includes manhwa (manga in Korean) character designers and illustrators working in Korea's video game industry.

Hong Kong, which historically has been at the crossroads of many cultures, is represented here by a multi-talented artist who is active in a broad range of disciplines, including graphic and interior design, art direction, book publishing, and

manhua (manga in Chinese).

The future is sure to bring an endless stream of artists from Asian countries whose professional development has been influenced by their absorption of the manga, anime, and video game culture. Although this book limits itself to artists from Japan, Korea, and Hong Kong, we hope that future volumes will introduce artists who hail from different countries and are expanding the boundaries of manga character art style even further.

Enjoy the wonderful artwork of these brilliant young artists!

—Rika Sugiyama

Kumiko

久美子

Kumiko's sumptuous creatures—fair maidens, supernatural beings, fairies, and winged angels—are drawn in brilliant colors. Her compositions are sometimes comical, sometimes serene illustrations of the beautiful fantasies she envisions.

Kumiko draws her characters with care and scrupulously embellishes their clothing and surroundings. Her meticulous attention to detail helps to create lovely, imaginary worlds that seem enticingly real.

Personal Data

Birthday:	July 1, 1976
Birthplace:	Fukuoka Prefecture, Japan
Gender:	Female
Education:	Kyushu Zokei Art College (design)
Working tools:	Primarily acrylic and acrylic gouache (Liquitex, Acryla),also transparent watercolors and Gansai (Japanese Style) watercolors (Holbein, Lorrain)
Favorite artists:	Illustrators: Naohisa Inoue, Yoshitaka Amano Artist: Shoen Uemura Picture book illustrators: Chris Van Allsburg, Irene Haas Creator: Craft Ebbing & Co.

Awards: The first Grand Prix to be awarded in *Comickers*: The Illust-Masters contest, honorable mention in the 22nd Poetry and Märchen Illustration Contest

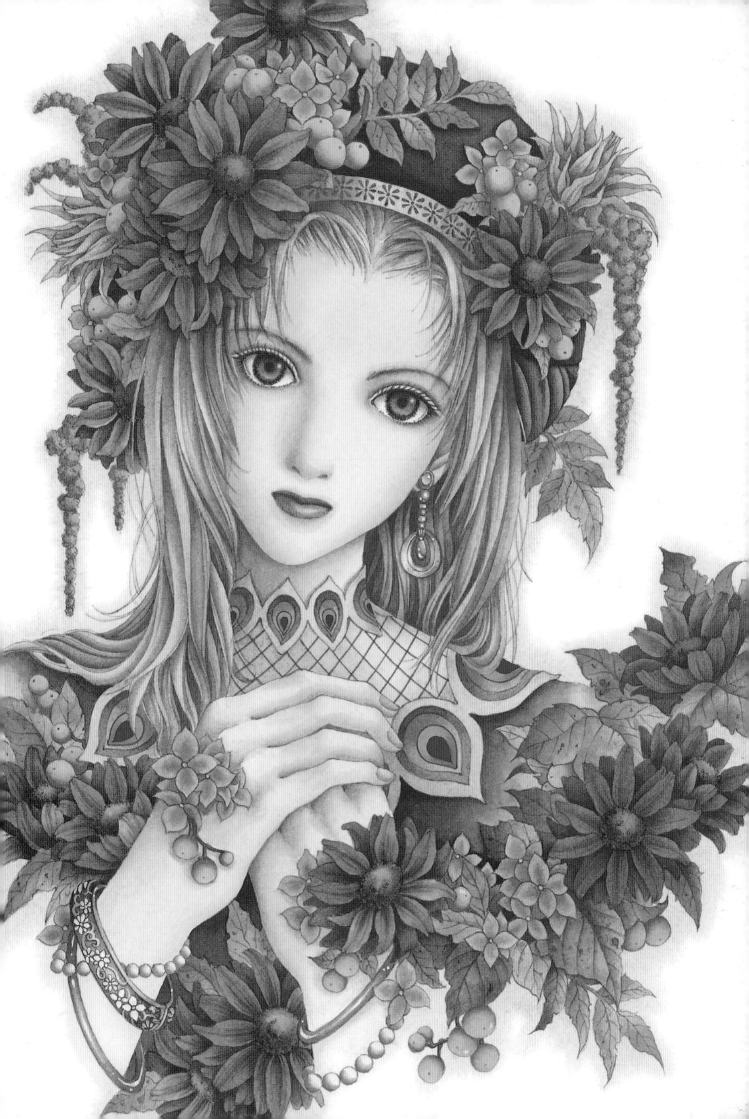

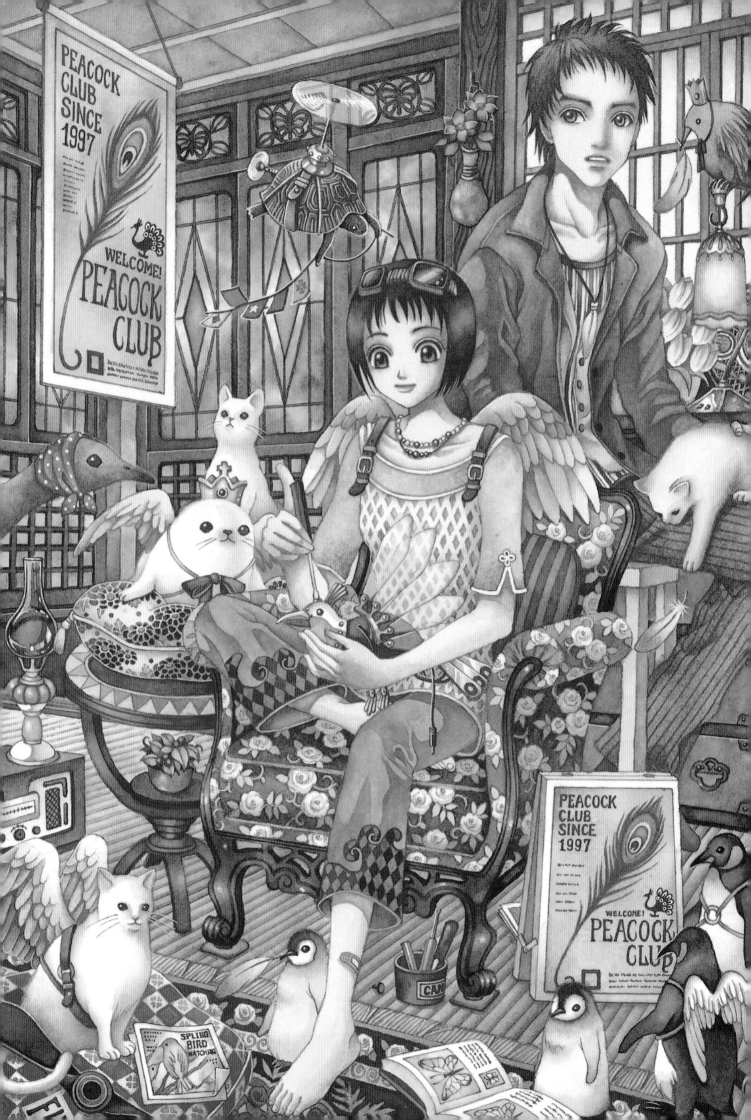

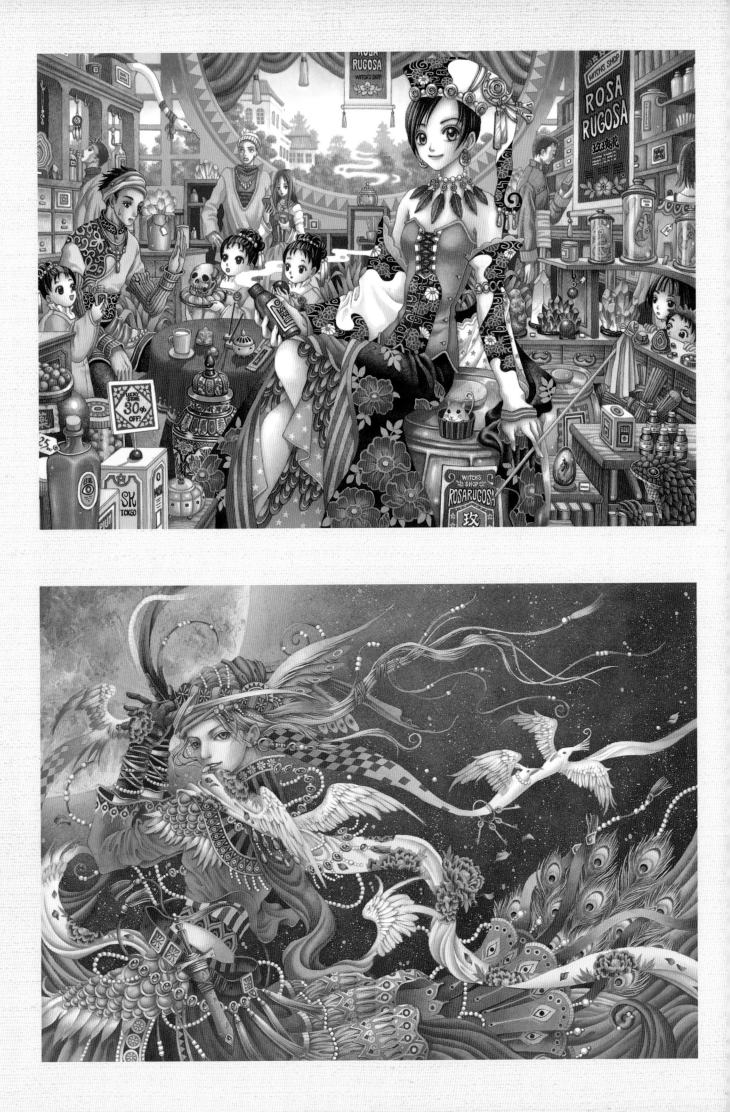

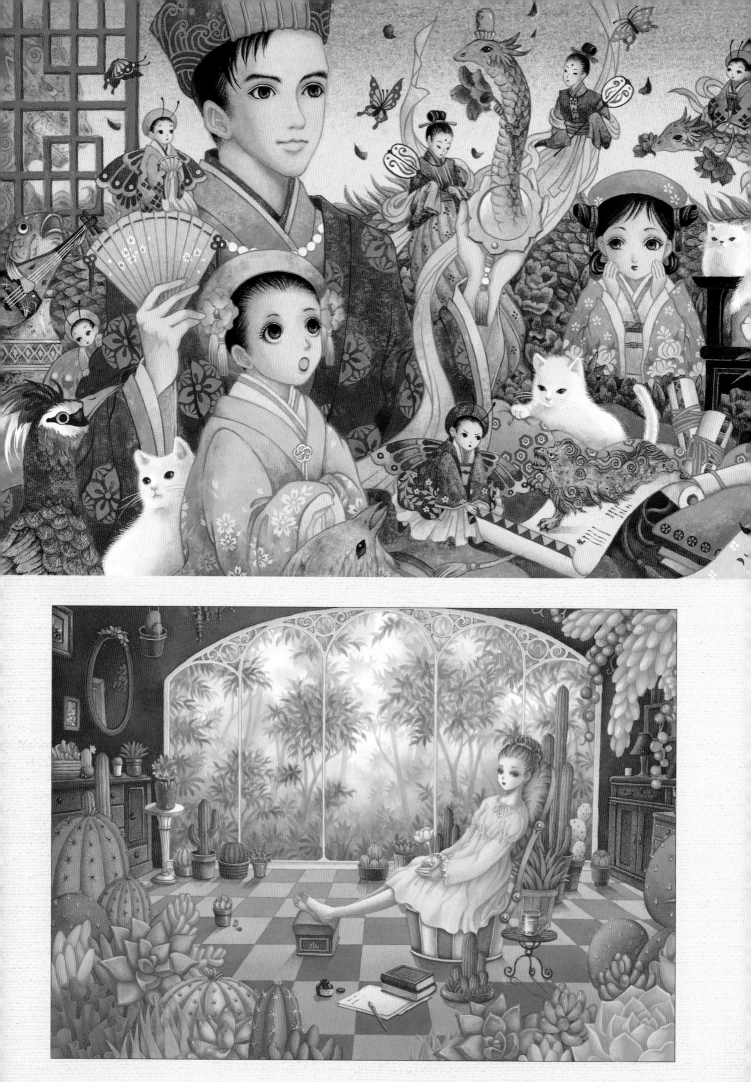

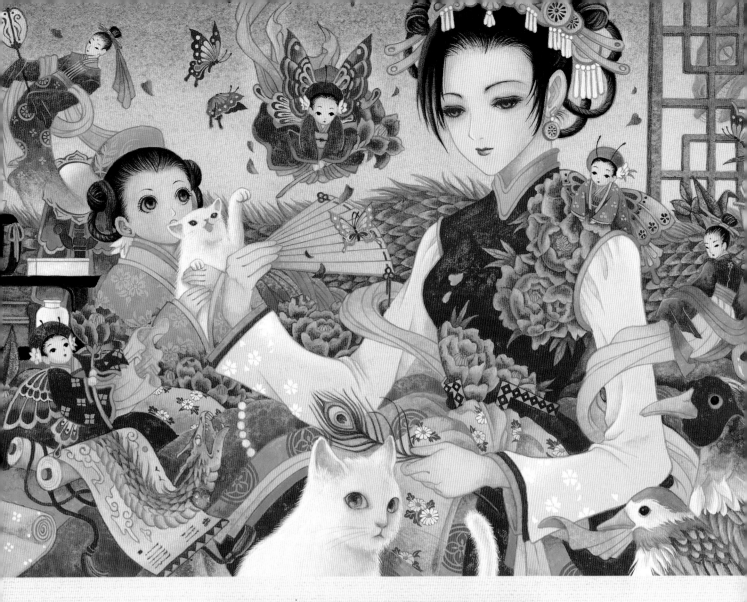

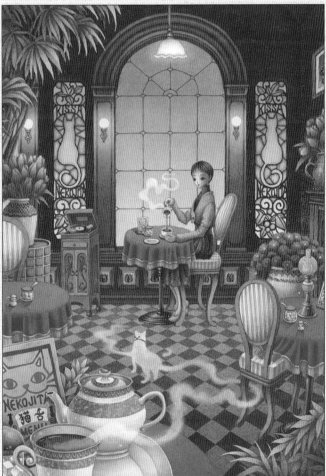

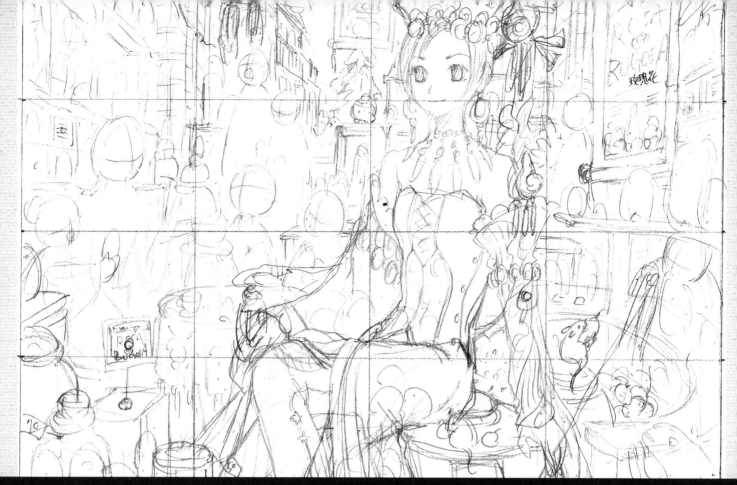

How I work

I make postcard-size rough sketches of all the ideas I get from looking through books on flowers, antiques, architecture, and interior design (especially those that combine Japanese and Western elements), or that occur to me when I'm just sitting around doing nothing. After I make a sketch, I set it aside for some time.

If I still like it when I come back to it, I will draw it in detail. It usually takes me about three days to finish a picture. Sometimes I use Iwaenogu (Japanese-style paints comprised of ground minerals that are mixed with glue). I like colors with a gray undertone, such as rikyunezumi (gray with an undertone of green) and a dark brownish green shade called uguisucharoku (uguisu means "nightingale" in Japanese). I use a lot of acrylic red, burnt sienna, and raw sienna.

The preliminary sketch for *The Peacock Club*, before I reworked some of the details (and added more to liven things up). I arrived at the concept for this picture by associating the ideas "wings —> creatures that can't fly —> a strange gathering."

Above is my rough sketch for *Rosa Rugosa*; I then add detail to get the preliminary sketch just right. I always pencil in the entire background, place it face up under a clean sheet of paper, and trace over the lines to make a copy of the picture on the sheet underneath.

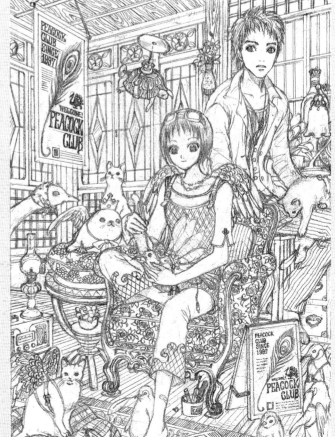

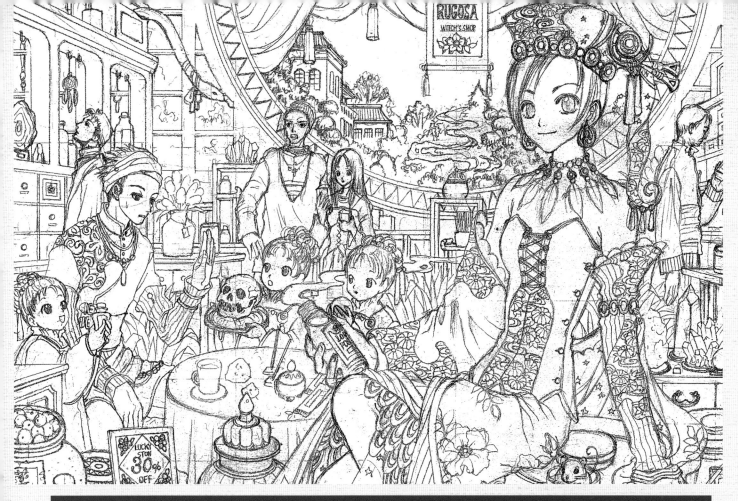

Guide to Illustrations

Autumn Colors
I had a hard time with this illustration because I don't do many close-ups of characters, but it was fun to draw all the flowers and leaves. I didn't do well on the hands, though. (p.11)

The Peacock Club, A Gathering of Creatures Who Aspire to Fly Gracefully Through the Sky
This group of would-be fliers is content just to strap on their decorative wings, talk about the sky, and make models of flying contraptions. I guess they're afraid they'll hurt themselves if they actually try to fly. The one that looks like a seal cub is the chairwoman. Her name is Princess, and her only job is to act enthusiastic at their meetings. (p.12)

The Witches' Shop: Rosa Rugosa
Rosa Rugosa sells a variety of items: ingredients and objects used to cast magic spells, minerals, incense, medicines, and lots more. Today's featured bargain is a Lucky Gold Skull. This has been on the shelf for years because it's disgusting and gives everyone the creeps. It's being offered today at a rock-bottom price! (p.13)

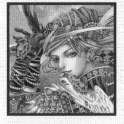

Lady Thief
Every night the lady thief appears in a town and carries off its treasures of gold and silver. Then she slips away with the ethereal ease of a bird in flight. She can't move an inch in these clothes, though, so you'll only see her dressed like this for five minutes on nights when the moon is full. (p.13)

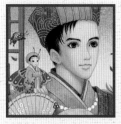

Sorcerers
These illustrations were my first experiences with rock-paint natural pigments (Iwaenogu). The set of two pictures portrays sorcerers, a sister (p. 15) and her younger brother (p.14), who've invited some children and animals to visit them. They're all having fun showing off their magic skills.

Like a Cactus
At the time I drew this picture, I was fascinated with cactuses and other succulent plants. Maybe I should have drawn more cactuses in this picture. Anyway, after I drew it, I lost interest in this type of plant. (p.14)

The Cat's Tongue Café
This is a book illustration for a little story about a boy who goes to a café where a mysterious, soothing bell rings whenever a cup of tea is poured into another cup to cool it off. (In Japan, someone is said to have "a cat's tongue" if he can't stand very hot food or drink.) My illustrations are always lively and colorful, so I had a hard time creating the subdued mood this picture demanded. (p.15)

joshclub

ジョッシュクラブ

joshclub's characters combine photographic realism with a soft, painterly touch. The characters' expressions are arresting, and as penetrating as those found on canvas. The worlds he illustrates are more diverse than reality.

joshclub says he gets inspired while doing mundane things like walking down the street, watching a movie, or shopping. He is fascinated by everyday life, which he transforms by adding a hint of the fantastic, transcending what is found in movies or even most manga.

Personal Data

Birthday:	December 17, 1977
Birthplace:	Seoul, Korea
Gender:	Male
Education:	Kyungmin College (comic art department)
Homepage:	http://www.joshclub.net
Address:	j@joshclub.net, joshclub@hanmail.net (msn)
Working tools:	Computer System Specifications:

Processor: Pentium 4 2.40GHz, Memory: 512MB, Video Card: nVIDIA GeForce4 Ti4200, Tablet: Wacom Intuos2 9x12, Display: Sony G420
Favorite artists: Robert Crumb for his powerful and passionate documentaries, Naoki Urasawa, Hiroaki Samura: *Mugen no Junin* (Endless dweller), Choi Ho-Chol: *Euljiro Junkansen* (Euljiro loopline), and many others.
Work experience: 1997: Ad illustrations for FEEL Production
2001-2003: Main character design for Digital Dream Studio TV series *PSI-KIX*
Since 2001: Conduct Painter Workshop in Hankyoreh Culture Center, Korea. Subcontracted illustration includes games, advertising, book covers, and fancy goods. Currently in the process of developing a MMORPG (massively multiplayer online role-playing game) for Nexon Inc. Art director, character design, illustration.

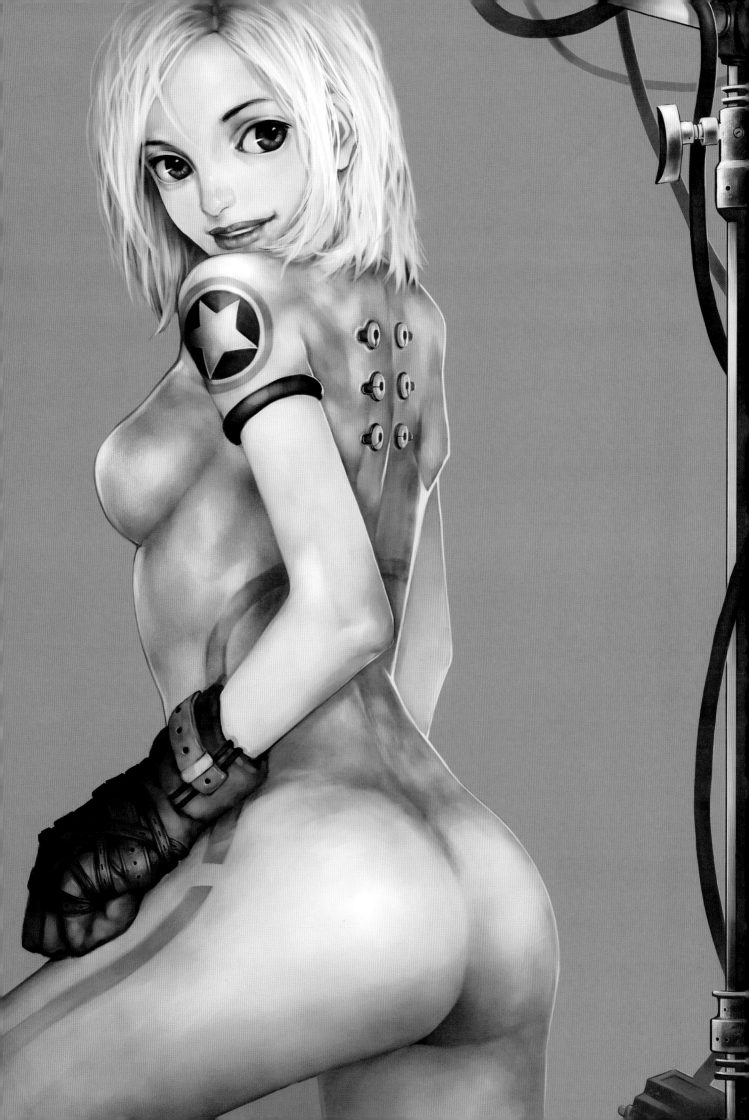

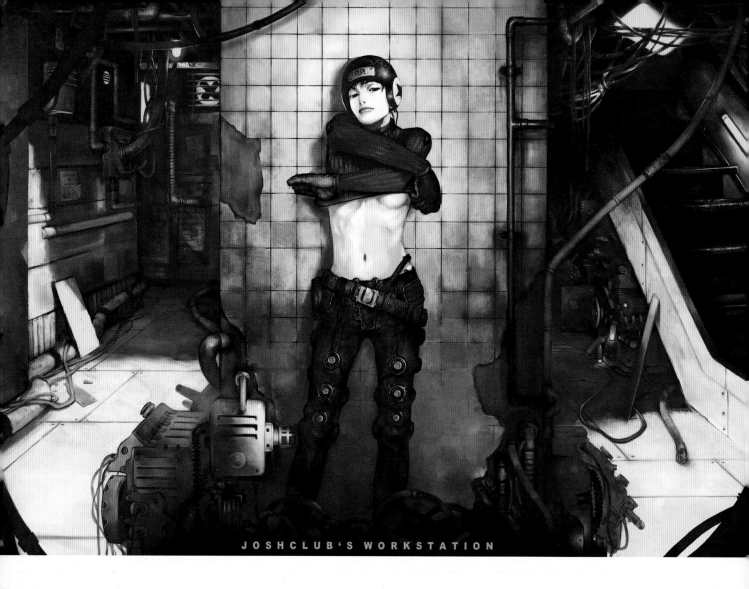

JOSHCLUB'S WORKSTATION

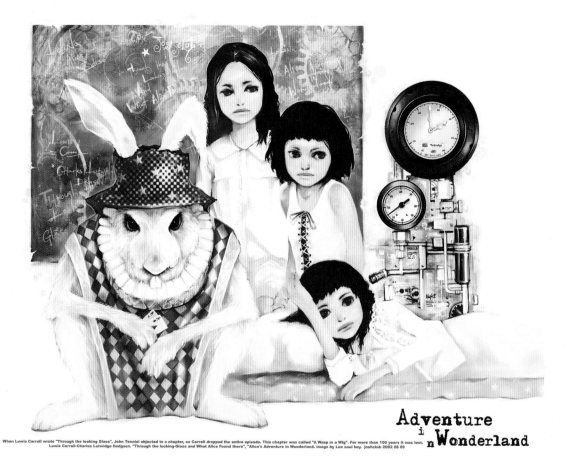

When Luwis Carroll wrote "Through the looking Glass", John Tenniel objected to a chapter, so Carroll dropped the entire episode. This chapter was called "A Wasp in a Wig". For more than 100 years it was lost.
Lewis Carroll-Charles Lutwidge Dodgson. "Through the looking-Glass and What Alice Found there", "Alice's Adventure in Wonderland. image by Lee soul key. joshclub 2002 08 09

Adventure
i
nWonderland

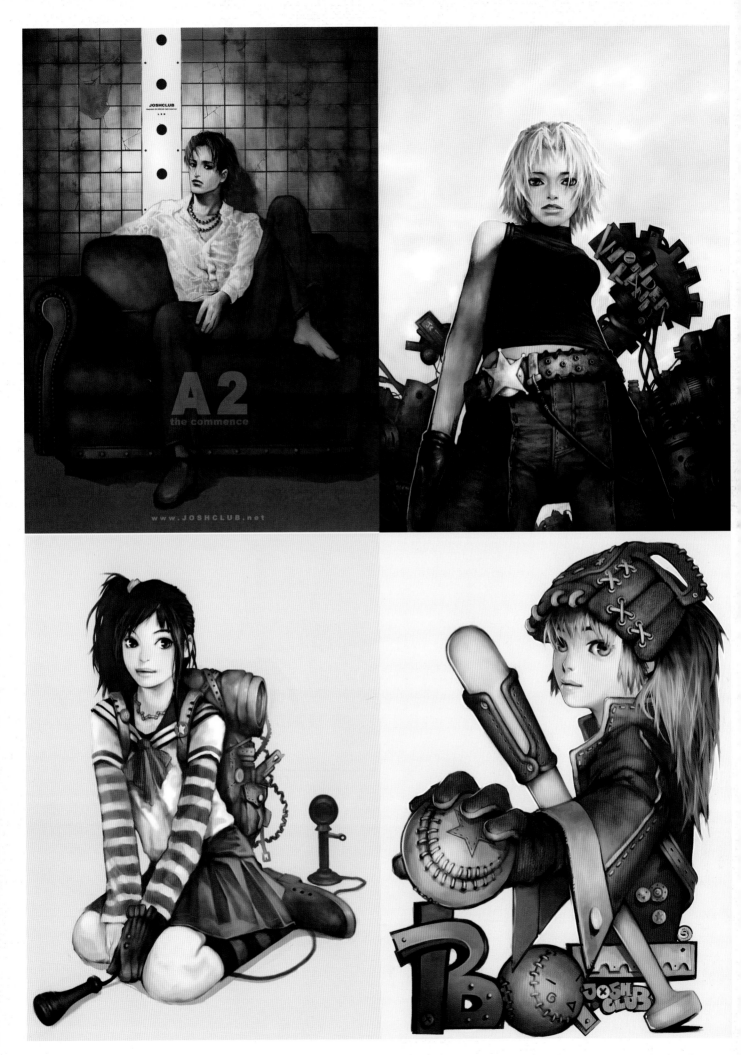

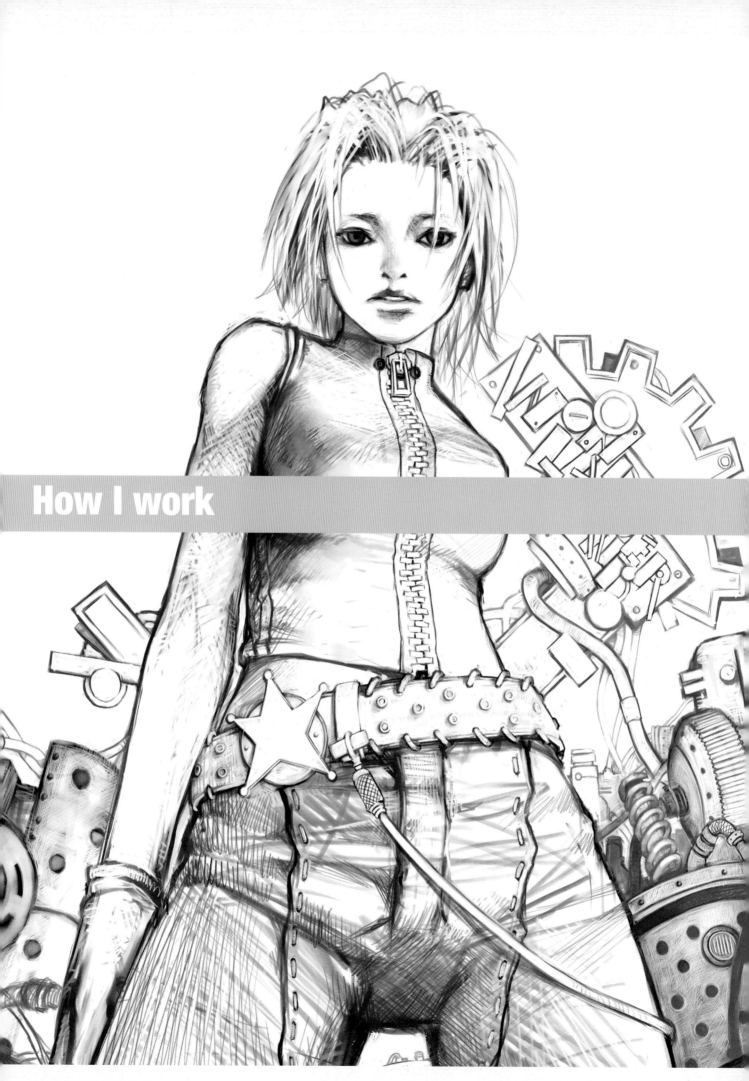

How I work

Q. Do you have a favorite motif?

A. I find the concept of "everyday fantasy" more interesting than anything else.

Q. Do you have any favorite colors, or are there any colors you use more often than others?

A. I'm personally partial to black, although I don't use it in my pictures.

Q. What other artistic genres would you like to explore?

A. I'd like to try my hand at animation—there are stories I want to tell and things I want to show people.

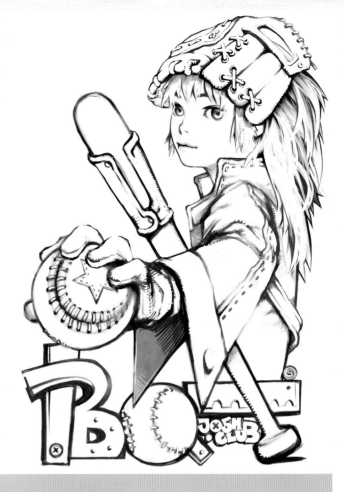

Wonderland & Bat sketch

Digital drawing is convenient; I've gotten so used to drawing with a tablet that now I do almost all of my sketches that way. But come to think of it, it's really no faster than sketching with paper and pencil.

Guide to Illustrations

Ivory

When I did this character, I focused on trying to make her sweet as well as sexy...well, it's a little hard to explain. Actually, the times when I perceive girls as sexy are just too numerous... (p.19)

Face

This is a series I've been drawing for a long time. I even number the images when I update my Web site, because there are over a hundred now. My original idea was to draw all kinds of faces with a variety of expressions...I guess. Somehow they've all begun to resemble each other and kind of blur together...(pp. 20—21)

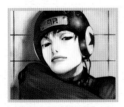

Helmet

I remember spending a pretty long time laboring over this one. The basic concept I had was of a sexy girl with tile in the background, but it ended up being much larger than I had originally intended. Looking at the picture again, I guess I made the face too large. I used the Painter 7.0 Watercolor Brush (a software application) to paint the dirt on the old tile so that it looked like it had dripped down. The track left by the dirt is so realistic it makes me think that the boundary between digital and analog drawing might really disappear someday. (p. 22)

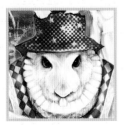

Alice

I love the story of Alice in Wonderland. My friend saw this picture and asked if this rabbit was the boss. (p. 22)

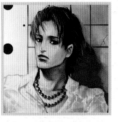

Chair

This man seems pretty intense. I wouldn't want to sit next to him, no matter what. (p. 23)

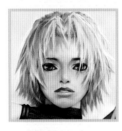

Wonderland

I was trying for a strange atmosphere, but I failed to convey the exact feeling I wanted. I did most of the drawing with Painter 6.1 Oil Pastel, and I really like the texture and natural look I got. (p. 23)

Uniform

A picture of a girl in uniform. When I was a junior high and high school student, I hated uniforms. But recently, when I see kids wearing uniforms, for some reason they look fresh and appealing. (p. 23)

Bat0:

This is an experimental picture I did for a digital illustration seminar I held. I drew it primarily to demonstrate how to utilize texture but, honestly, I don't think two hours is enough time to draw this properly. I used Painter 6.1 Oil Pastel, Square Chalk, and Simple Water (software applications). (p. 23)

Imperial boy

帝国少年

Architectural structures at once nostalgic and futuristic, streets bustling with activity: such images convey a clear picture of the urban experience. These imaginary, labyrinthine cities seem to have a history all their own—as if they developed over time, keeping pace with their inhabitants' evolving thoughts and feelings.

Imperial Boy loves to draw scenes reminiscent of the Meiji, Taisho, and early Showa periods in Japan, when there was a curious mixing of cultures (for example, people would combine traditional Japanese dress with Western attire). He also likes to portray events commonly found in Asian cities, from the jumble of human activity in the streets and alleyways to more leisurely neighborhood scenes. Filtered through his imagination, such familiar worlds are transformed into new, fantastic metropolises. Take a walk and explore the captivating sights in these marvelous cities.

Personal Data

Birthday: March 1, 1976
Birthplace: Tokyo, Japan
Gender: Male
Education: Chubi Central Art School (professional art school)
Homepage: Teicoku Syounen http://www12.big.or.jp/~botan/index.shtml
Address: botan@big.or.jp
Working tools: Computer System Specifications: Handmade computer (Operating System: Windows 2000, Memory: 512MB, Processor: 2.4G, Hard disk drive: 240GB, Software: Photoshop and LightWave 3D, Tablet: Wacom)
Favorite artists: Tatsuyuki Tanaka, Hiroaki Kogura, Yoshiyuki Sadamoto, Takuhito Kusanagi, Akihiro Yamada, Range Murata, Katsuya Terada, Takayuki Takeya, Shigeki Maejima, Kouhaku Kuroboshi, Naohisa Inoue, Katsuhiro Otomo, Koji Morimoto, Kamui Fujiwara, Masamune Shirow, Mamoru Oshii, Hayao Miyazaki, Mamoru Nagano, Buichi Terasawa, Yang Kyung-il, Yukito Kishiro, Minoru Furuya, Hiroki Endo, Makoto Shinkai, CLAMP, Rokuro Shinofusa, Hiromu Arakawa, Ken Akamatsu, Tomomasa Takuma, Kentaro Miura, Gonzo, Production IG, Studio Ghibli, Studio 4°C, Jiro Akagawa, Yoko Kanno, Susumu Hirasawa, Michael Ende, Fuyumi Ono, and many more.
Work experience: Since 1996: Work for several game software companies
2002: Sale of digital prints through the IPM Art Shop (Internet)

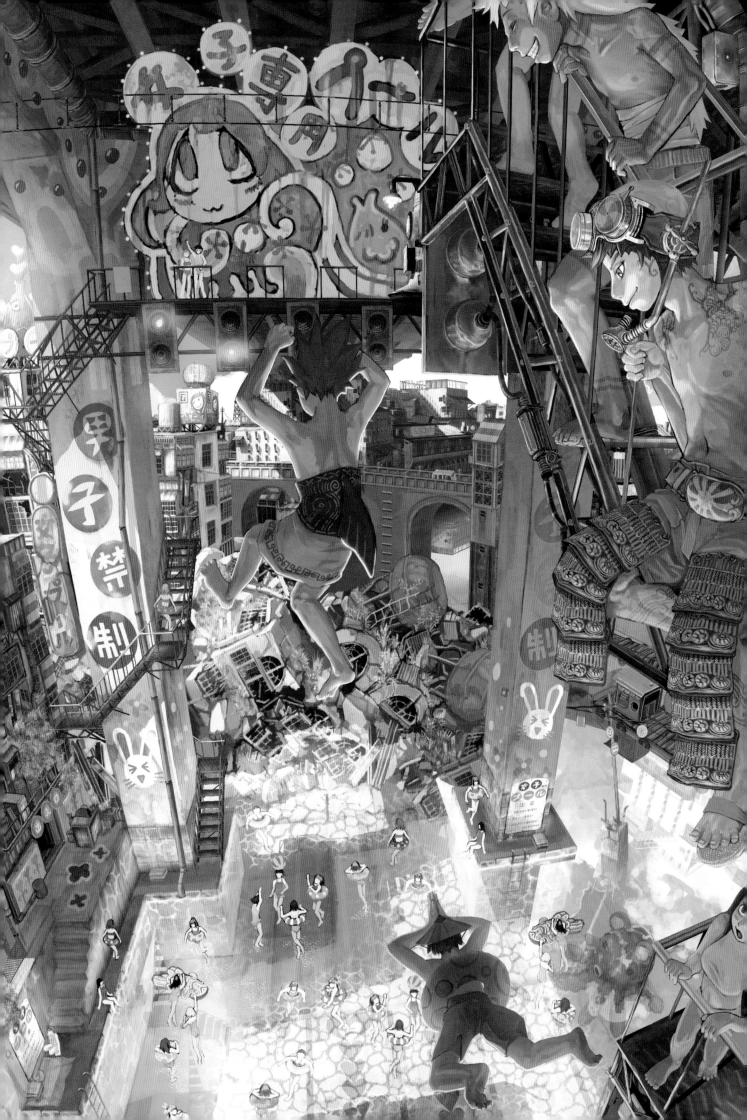

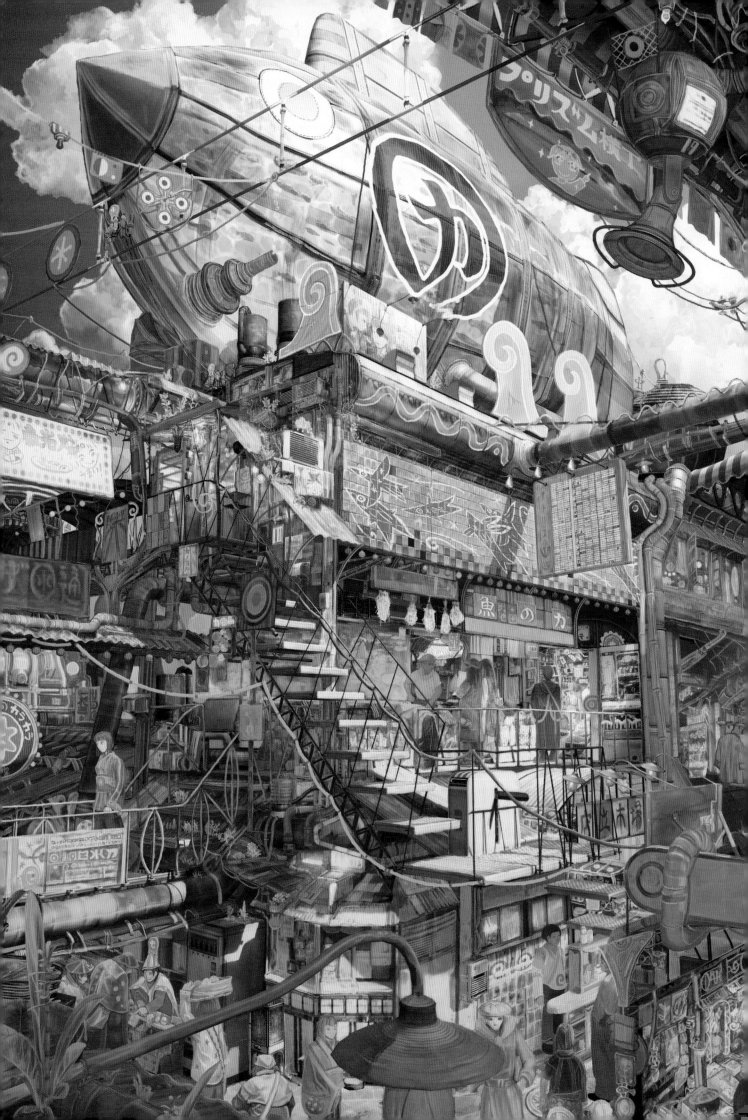

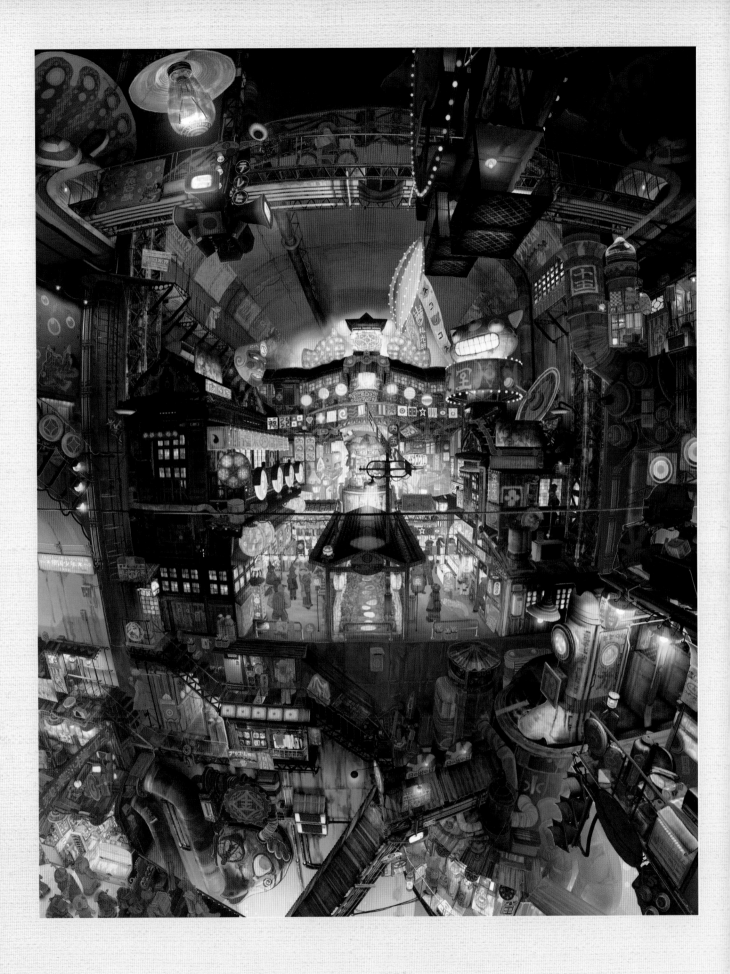

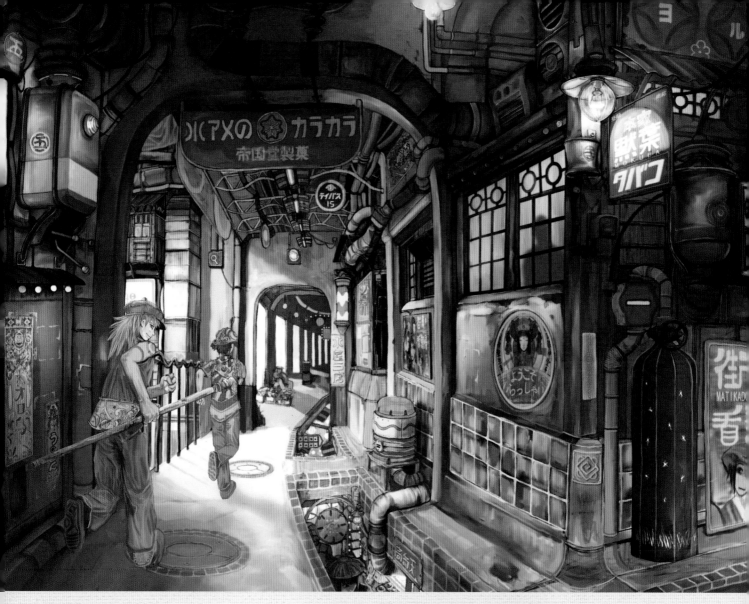

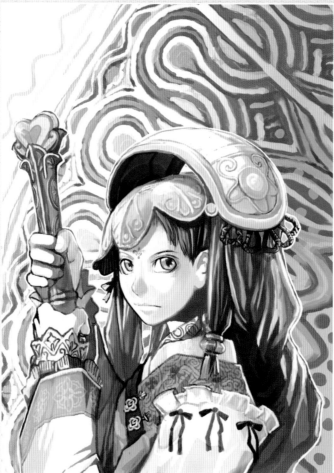

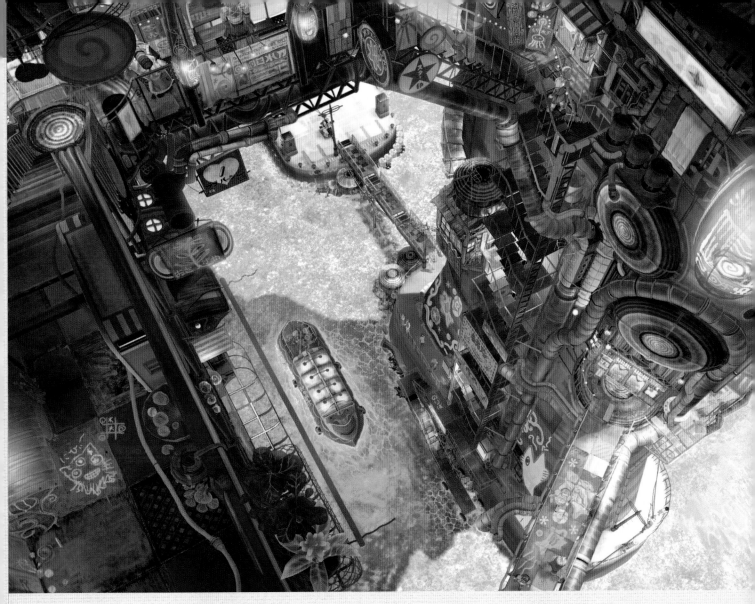

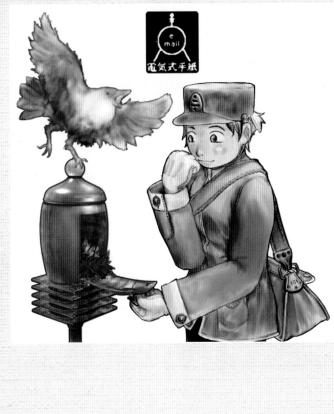

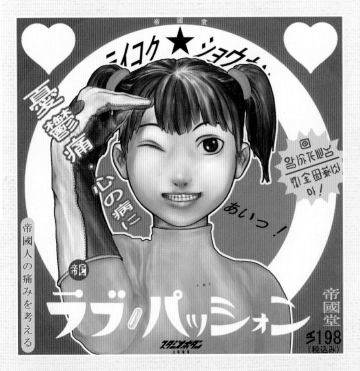

Step by Step

1 I do backgrounds with 3D software, so I'll discuss that process. First I do a rough sketch. I add perspective with software, so the rough sketch is a design drawing that shows what goes where (organization) and camera angle (composition). (1 day) Then I decide on how to do the shading. I determine an approximate position for the light source to bring the image into focus. (2 days)

2 I decide on overall coloring and do a rough drawing of the reflections on the surface of the water to bring the image into clearer focus. (1 day) I color the picture starting with the posts. When you're filling in color with 2D software you have to consider perspective, so to save time I used 3D software. (1 day)

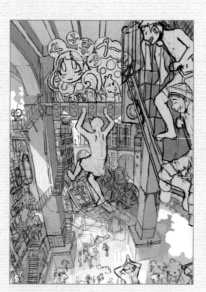

3 On the other hand, some things take longer with 3D software; for those, I use 2D. Keeping the light source in mind, I do the shading. (More than 2 days) I create a suitable background image from what's available. To get a hand drawn effect for the overall image, I retouch it over the photo with 2D software. (1 day) Then I draw in the characters to finish the picture. The finished work is on page 27, so take a look.

Boys

I had boys, summer, and adventures in mind when I did this picture. The composition is vertical, so the perspective is from above. I associated adventure with exploring in the rubble and vacant lots; summer with the ocean, water, and pools; and boys with a healthy dose of sexual curiosity. (p. 27)

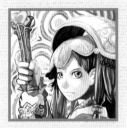

Princess Goddess

I was inspired to do this picture by Japanese clothing and ethnic costumes I saw on a TV program or somewhere. I took special care with the character's coloring. (p. 30)

Marine Products Store "Fish Power"

I had two ideas in mind when I created this picture. One was to depict life in the intricate maze of shops and buildings you find in Asian cities. The other was to infuse the picture with the special energy of summer by adding things associated with water. (p. 28)

By the Sea

I like the idea of looking at the brilliant blue of the sea sparkling in the sunlight from a shadowy or concealed vantage point. I aimed for that effect in the picture. I was particularly careful with the color of the water and the varying degrees of light on the sunlit portions of buildings. (p. 31)

4th Street

This is a picture of an image that came to me suddenly one day. Here, people are living in a part of the city that they built in an abandoned underground tunnel. (p. 29)

Hey, what happened to the mail?

When I drew this, I had been thinking about the kind of bizarre accidents or events that are so strange, it's hard to believe they actually happened. (p. 31)

Back Street

Some back streets in Hong Kong and other Asian cities are gloomy even during the daytime; there's something a little threatening about them that gives you a strange feeling of excitement. I drew this picture to capture that sensation. (p. 30)

Love Passion

For this picture I had in mind the signboards, wrapping paper, and ads with a vintage look that date from the early Showa period. (p. 31)

Ryusuke Hamamoto

濱元隆輔

Pretty girls full of spirit and energy, caught in a moment in time; mischievous girls with smiles suggestive of mercurial cats.

Ryusuke Hamamoto's illustrations incorporate a range of elements—decorative horns, cat's ears, frills and lace, the angel-and-devil motif, and even macho muscles. Common to all of the characters are their appealing expressions that charm the viewer. Try and imagine the stories behind them.

Personal Data

Birthday: February 16, 1981
Birthplace: Tokyo, Japan
Gender: Male
Education: Currently enrolled at Tokyo Polytechnic University (Faculty of Arts, Department of Design)
Homepage: K***, http://home9.highway.ne.jp/kool/
Address: kool@a5w.highway.ne.jp
Working tools: Computer System Specifications: eMac (Operating System: Mac OS 9.2, Memory: 768MB, Processor: 700MHz, Hard disk size: 80GB, Software: Photoshop 4.0J and Painter 6.0J)
Favorite artists: OKAMA, Takamichi, Kouhaku Kuroboshi, Mike Mignola (I'm madly in love with him!), Akatsuki Gomoku, Shio (designer for Konami)
Work experience: Cover and illustrations for the novel *Kero Kero, The Oath of Green* (Tokuma Dual Library), illustration for the reader's column of the monthly magazine *Game-Gather* (Hobby Japan), creature design for the PlayStation 2 game *Fullmetal Alchemist* (Square Enix), many other manga and illustrations

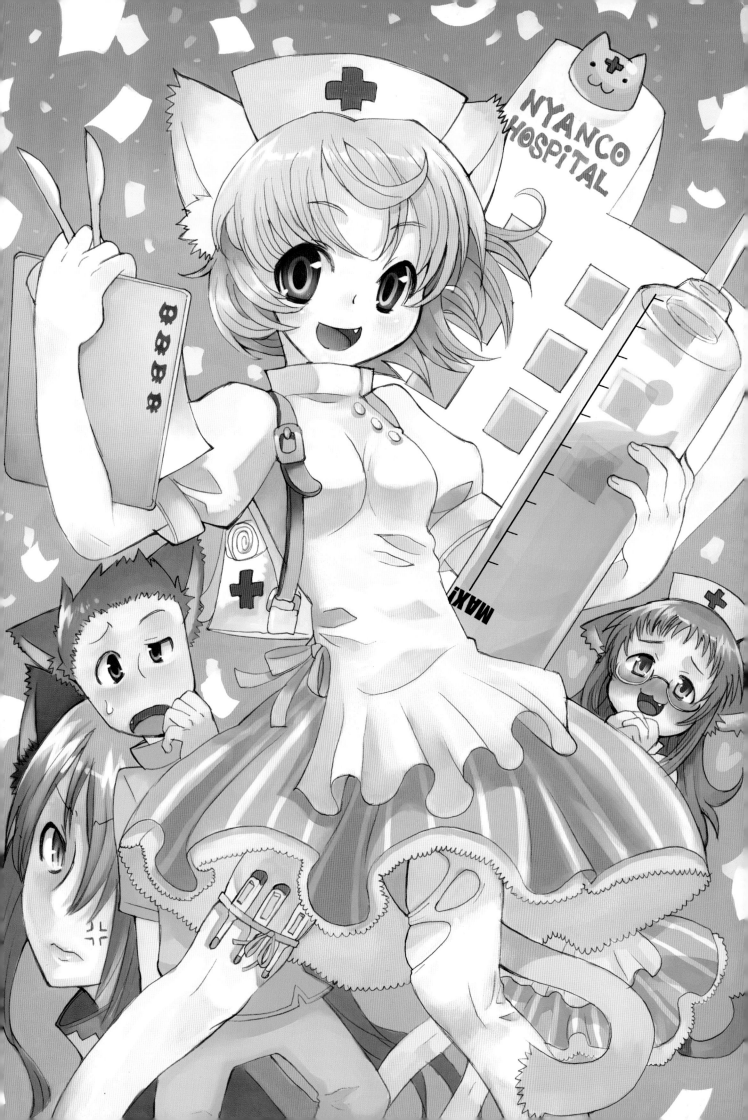

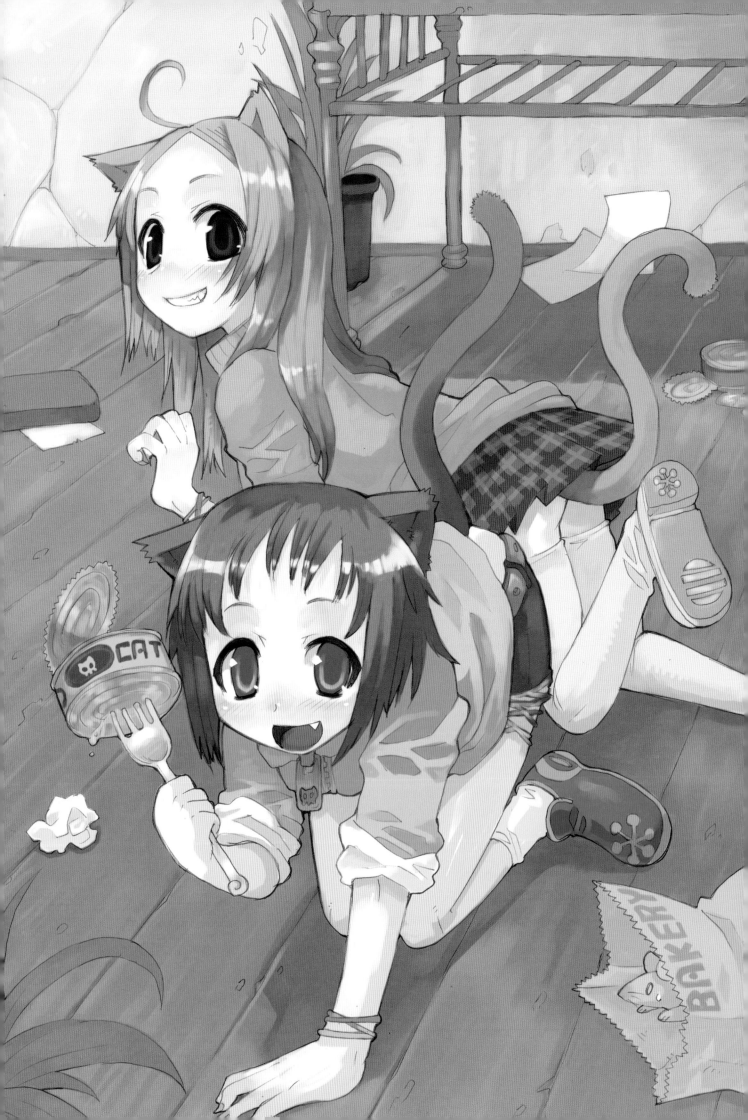

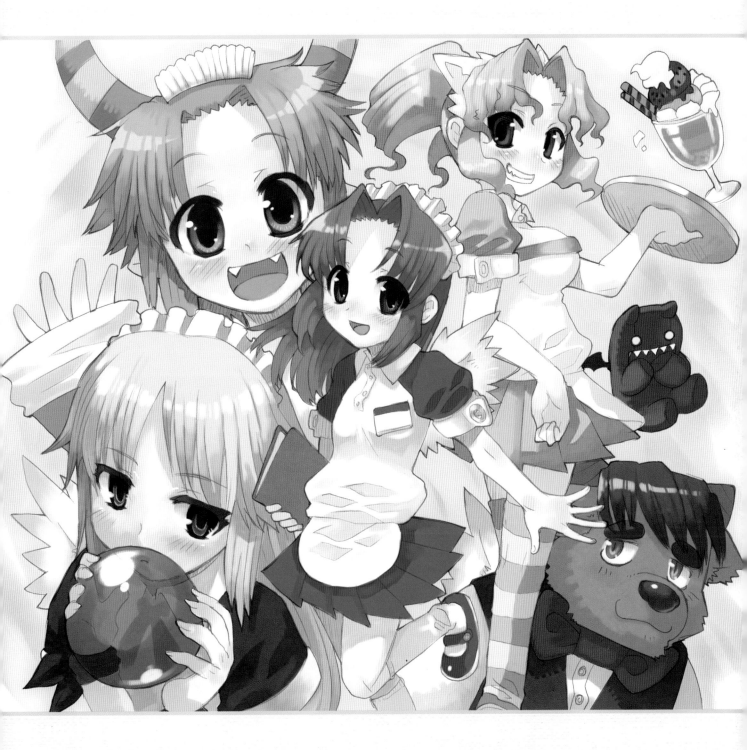

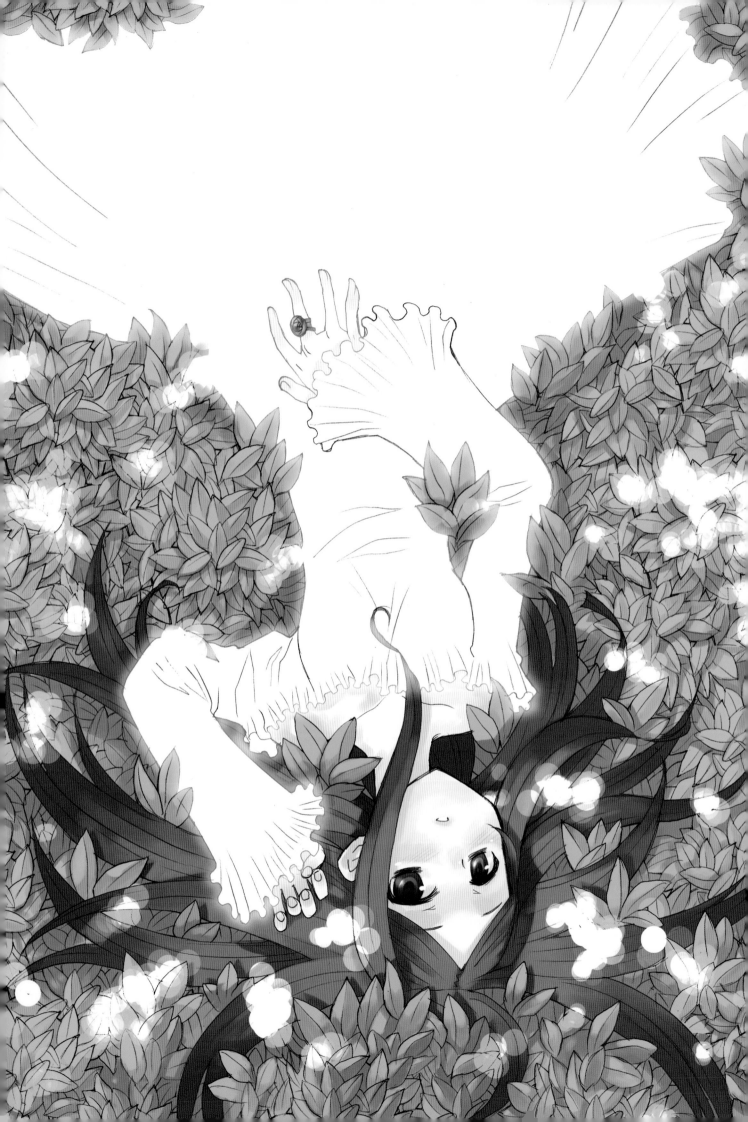

SHIFT

ALT

OPT

A.I.units

Step by Step

1 I scan the line drawing into the computer, add contrast, and remove the junk. I make separate layers for background and character coloring and color them in. The coloring is temporary; I just do this to distinguish between the two elements. Then I paint the picture with an airbrush.

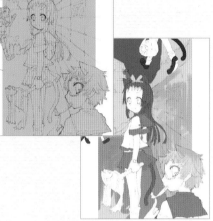

2 First I paint the background. I'm careful to paint the street and the dirt on the wall with a gradation of shades that look natural. After carefully painting the mortar between the bricks in the brick fence, the plastic bottle across the street, the traffic sign, and other elements, I make corrections for colors that have run over or places I forgot to paint. Finally I add highlights, and the background coloring is finished. But if I notice things I don't like while I'm painting the characters, I make as many corrections to the background coloring as are necessary.

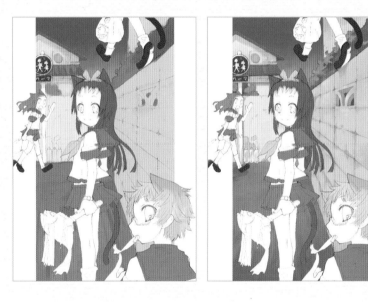

3 I paint the basic shading on the characters. Then I begin painting the central character. I start with the face and work slowly, because it's a very important element. Over the base color for the skin I paint a color that is a shade darker, in order to get a more finished look. I find that adding a slightly different hue produces depth.

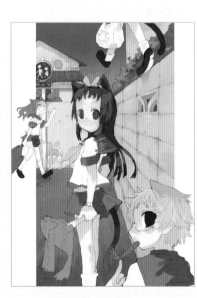

4 I paint the eyes and hair. First the eyes: I go over and over them until I get exactly the effect I want. After painting the hair its basic color, I apply different shades to the area. Then I add highlights. When I do this, I'm always careful not to overdo it or make the highlights look too obvious.

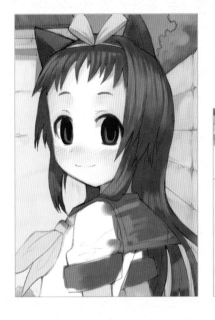

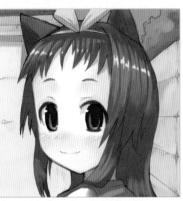

5 Next, I paint the character's sailor-style school uniform and the small object she's holding. I vary colors slightly so the shading doesn't become dull. I want the fish to be an accent in the picture, so I give it impact by painting it red.

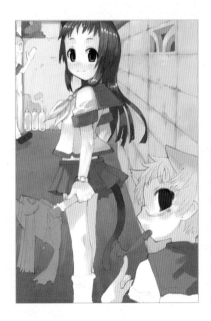

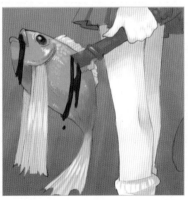

6 I paint this character next, following the same steps. Because she's in front, I'm very careful with detail. I make her more interesting by adding a little orange to the skin color. I do the basic shading on the hair, then carefully add detail, taking into account how the hair is layered. When that's done, I add highlights.

7 I paint the glasses, choosing colors for the reflection in the lenses that will stand out against the overall color scheme. I highlight the lenses to convey the texture of glass. I paint her fingernails yellow to help make her cute. I finish this character by painting her school uniform, the fish she's holding in her mouth, and other details.

8 Finally, I paint the character in the background. I use the same process, but keep the colors simple. I also paint the character on the fence. Only the feet are visible, so I give the character individuality with the look of the shoes and the design and texture of the plastic bag.

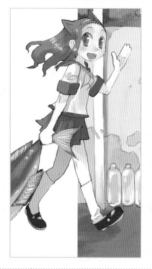

9 I check the overall balance of the image. The background seems to need a little red, so I adjust the coloring. The difference is most noticeable in the area of the asphalt, don't you think? The last thing I do is paint the white frame dark brown to give the picture a crisp edge. It's done.

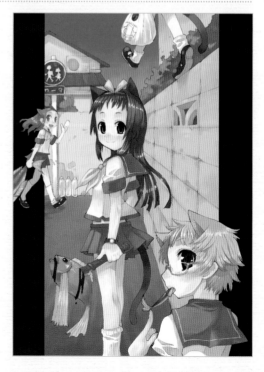

Nurse With Cat's Ears

I risked my life making her tights look sexy. (p. 37)

Two Girls With Cat's Ears

I thought their little cat's ears were so adorable that I drew them to look like accessories. (p. 38)

A Picture of White Chaos

This is bright and fun. (p. 39)

Magnificent Funeral

I've wanted to do this kind of picture composition for a long time, so I gave it my best shot. (p. 40)

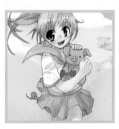

Girl With Pig

I had in mind a cross between a country girl and the girls in "gal games" (computer-simulated romance games) as the concept for this character. (p. 41)

Three Girls

The girl with pigtails and antennas is one of my favorite character designs. (p. 41)

Cover Girls

I tried to draw characters that would really catch your eye. (p. 41)

MAXX

マックス

Maxx's sensual characters—both male and female—project a larger-than-life presence that looms from the computer screen. Black is his favorite color; intense shades generate substance.

His solidly realistic artwork (thanks to his skillful brushwork) belies the fact that it is done on a computer. This realism is seen in the many characters shown here that were designed for Korean computer games.

Personal Data

Birthday: December 10, 1981
Birthplace: Seoul, Korea
Gender: Male
Education: The Korean National University of Arts (Bachelor of Fine Art in animation)
Homepage: MAXX SOUL, http://maxxsoul.com
Address: maxx@maxxsoul.com
Working tools: Computer (both scanned pencil sketch and tablet)

I mainly sketch with pencils and mechanical pencils, then scan sketches into the computer to do coloring. When I want to do free drawing to give form to the ideas in my head, I sketch directly into the computer with the tablet, because it has the advantage of letting me sketch and alter ideas at will without restrictions of materials and space. But compared with pencil and mechanical pencil sketches, it's more difficult with a tablet to get a precise facial expression or render a line exactly the way you want it. That's why I sometimes use the two methods in tandem.

System Specifications

Computer: Power Macintosh G5 (Processor: Dual 2GHz PowerPC G5, Frontside bus: 1GHz, L2 Cache: 512K per processor, SDRAM main memory: 2GB, Hard drive: 160GB Serial ATA, Optical drive: SuperDrive, 8x AGP Pro graphics: ATI Radeon 9600 Pro with 64MB of DDR (video memory), System software: Mac OS X.3 Panther)

Windows-based computer (Processor: Pentium 4 2.6C GHz, Memory: 2GB SDRAM, Graphics: ATI Radeon 9600 Pro, Hard drive: 120GB + 80GB Serial ATA, Operating system: Windows 2000 Professional)

Tablet: Wacom Intuos2 6x8, Printer: Epson Stylus Photo 2200 Inkjet, Displays: Sony FD Triniton GDM-FW900 (24") and Eizo T966 (21"), Software: Photoshop 7.1 and Painter 6

(sometimes Painter 7 and 8)

I use the Mac for technical work and the Pentium 4 computer for a little 3D work and Internet-related business. I mainly use Photoshop for coloring and Painter for drawing. I use Photoshop for brushwork a lot more now, though, because the upgraded versions have made continued improvements to the brushes so that they are beginning to rival Painter brushes; the boundary between the two programs is breaking down.

Favorite artists: Manet, Frank Frazetta, Ashley Wood, Katsuhiro Otomo, Kinu Nishimura and Bengus (CAPCOM designers)

Work experience:

1998: Comix Public Subscription, Seoul Media Group Inc.

2000: Illustration of advertisement materials and posters for *Arcturus*, a role-playing game developed by Sonnori Co., Ltd. and Gravity Corp.

2001: Main character design and illustration for Sonnori's *Astonishia Story 2*, ad poster illustration for Sonnori's *Forgotten Saga 2*, pinup illustration for *error: Manga Collection*, published by Bijutsu Shuppan-Sha.

2002: Main cover illustration for fantasy novels published by Chungeram.

2003: Concept design and main ad poster illustration for *Metin 2*, an online game developed by Ymir Entertainment; main artwork director for *Soulless*, a PlayStation 2 game developed by Sony Computer Entertainment Korea and Sonnori published by Chungeram.

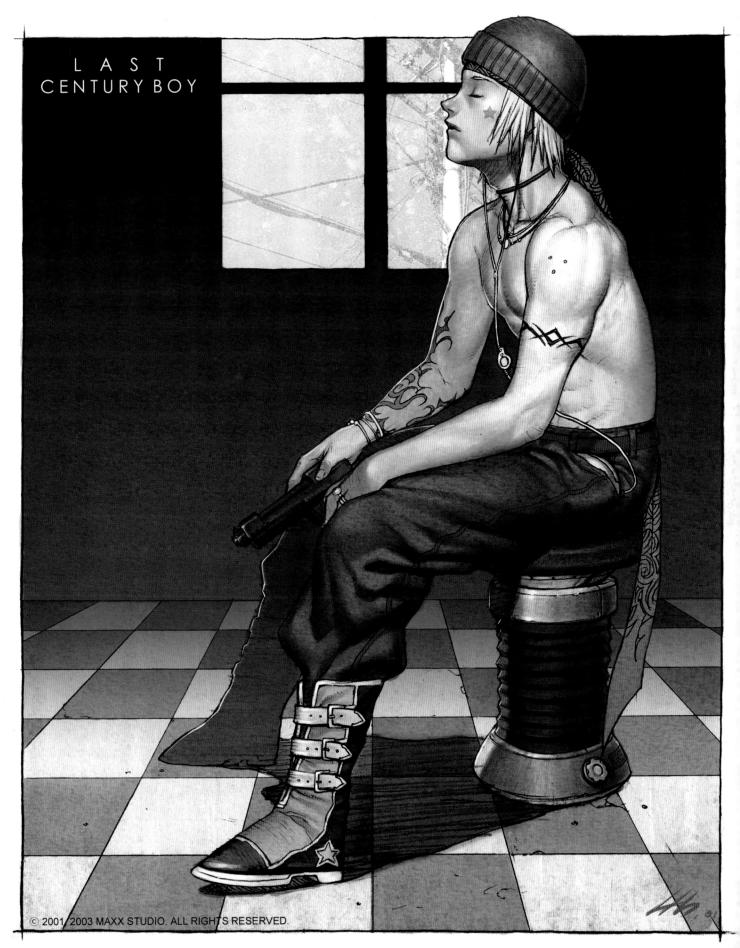

LAST
CENTURY BOY

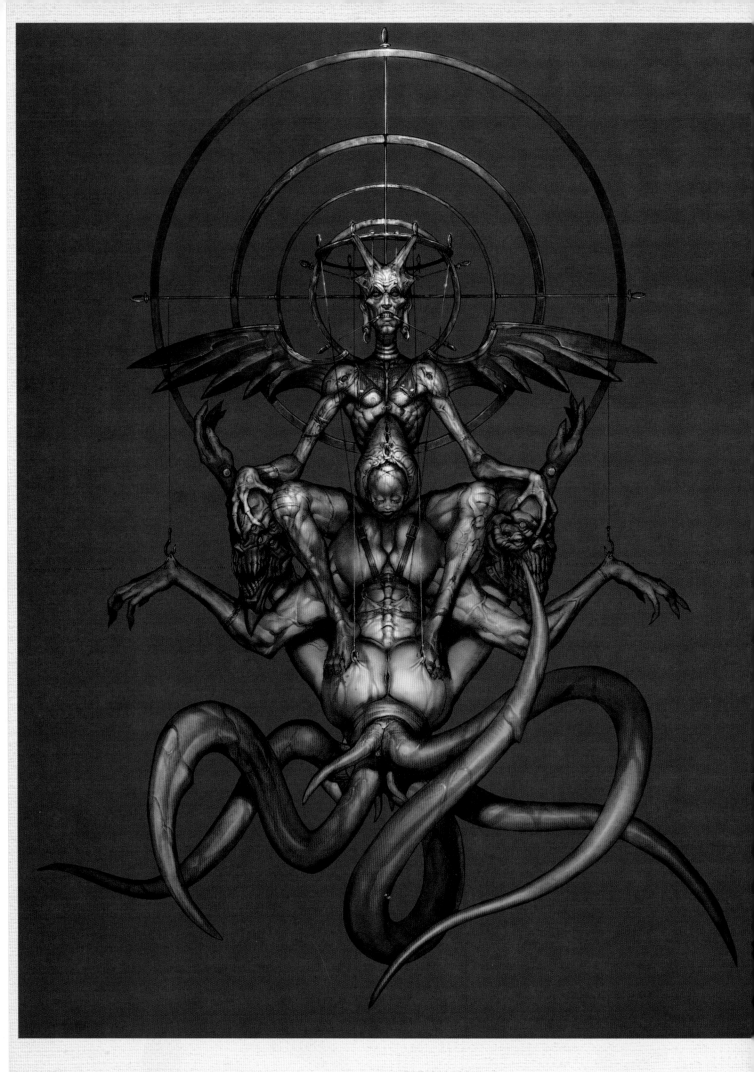

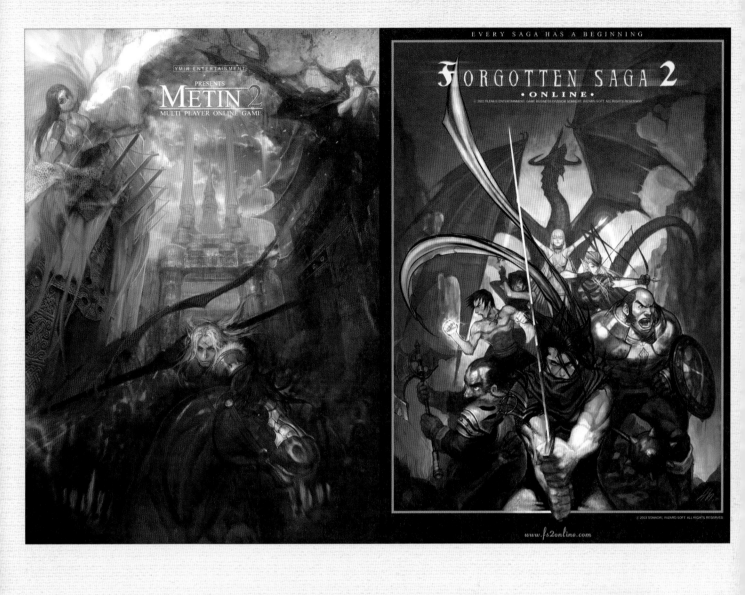

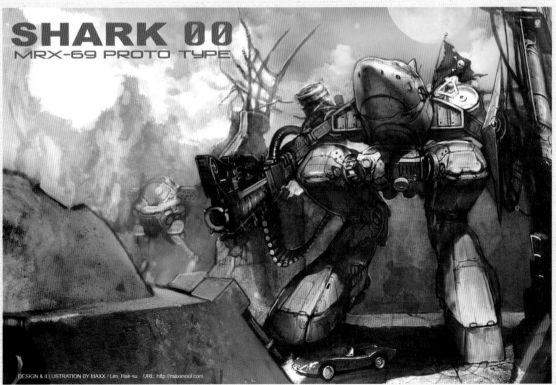

Soulless character design-Vantaech

Untitled

How I work

I sketched this with a pencil to work out design details and motion. The character in the photo is a Tibetan-style gypsy.

1. How long does it take you to create an image?

The time required for a drawing depends on its scale and subject. My conceptual sketches usually take about 30 minutes.

2. Do you have a favorite theme?

It's "living." I'm fascinated by the variety of lifestyles found in different cultures. I'm also interested in fashion. Music stimulates my imagination and makes me want to give expression to it.

3. Do you prefer to work with any particular colors?

I love black, but I find it more satisfying to use a variety of colors rather than a single shade. I like adding a small bit of primary color to a picture with a dark color scheme.

4. In the future, what other fields would you like to explore?

I find the idea of creating new worlds with games, animation, and movies very appealing. I would also like to try my hand at fashion illustration. Currently, I'm involved in some projects in the game industry and am working hard to make those a success. At the moment, my main objective is to create artwork that I hope people will find surprising and pleasurable. I'm expecting to do even better work later on. Don't miss it!

Here I'm doing the rough sketch of a character who is a dwarf. First I used a pencil, then went over it with a brush to achieve stronger lines. After finishing the brushwork, I colored the sketch but kept shading to a minimum to emphasize the strength of the lines.

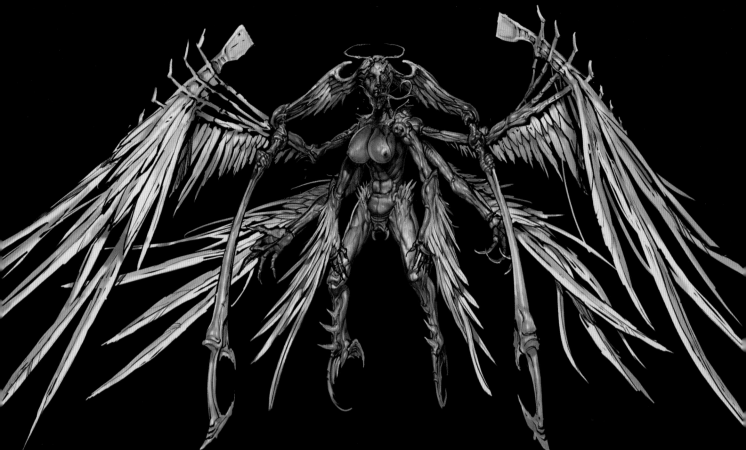

This is a rough sketch for a color illustration. I use a tablet when I want to sketch ideas as they come to me.

Fallen angel

Guide to Illustrations

Last century boy

This is an illustration of an idea I had for a character who is living in an earlier time. As you can see, he is deep in thought. (p. 47)

"Soulless" character design-Ren

Here is an Asian elf that plays with the popular classical Western notion of the blond-haired archer elf. Ever since I went to an archery tournament and saw with my own eyes the exceptional skill of Korean archers, I've wanted to design an Asian elf. This game was my chance! (p. 48)

"Soulless" character design-Diren

To retain the look of a brush illustration, I kept coloring to a minimum. Unfortunately, polygon restrictions meant I had to reduce the amount of colorful Tibetan accessories. (p. 49)

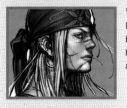

"Soulless" character design-Meltz

I designed this character with a tattoo, a bandanna, and a chain. He doesn't have a big build, but I created him to look both muscular and agile. (p. 49)

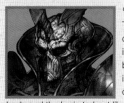

"Soulless" character design-Hellord

The motif for this character was a skull and bones; I designed him so that the skull would be silhouetted in the dark. Although they have a human form, the bones are made from dragon bones, so they are indestructible and threatening. The character configuration calls for frosty air to emanate from the body and the brain to beat like a heart and give off light. (p. 49)

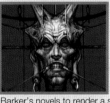

"Soulless" character design-Phrostie

The idea was not so much to emphasize the character's charisma as to create a personality that combines slyness with sensitivity and good manners. Rather than a masochistic tool, the wire hook is really a solace for the soul; I got this motif from the movie *The Cell*. I drew heavily on Clive Barker's novels to render a sense of the grotesque. (p. 50)

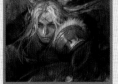

Metin 2

This is a poster for an online fantasy role-playing game set in the Middle Ages in Europe, the Middle East, and Asia. I had never worked on a project of this scale before and I didn't have the luxury of time, so I recall being pretty bewildered. I did lots of experimental work for this and learned quite a bit; it turned out to be a very meaningful project for me. (p. 51)

Forgotten saga2 online

This is an early illustration I drew with Photoshop. It depicts a group of adventurers who all have different occupations and are of various ethnic origins. (p. 51).

SHARK 00

I like combining the image of a shark with that of a classic fighter. I really enjoyed working on this illustration and was happy to get the chance to draw a robot series. (p. 51)

OPON

オーポン

Spirited faces are the result of OPON's refreshing touch with color. Because many of these characters appear in computer games, each of them needs a commanding presence. Lively facial expressions make these creations more real for the player.

OPON designs all types of individuals—pretty girls; cool, handsome guys; gruff, middle-aged men. He dresses them in clothes and accessories reflecting their personalities. Enjoy these one-of-a-kind characters, born from a unique sensibility that strikes just the right balance between manga-style representation and realism.

Personal Data

Birthday: September 18, 1977

Birthplace: Seoul, Korea

Gender: Male

Education: Jakarta International School (Indonesia), currently on leave of absence from a public university (industrial design)

Address: 44mag@nownuri.net

Working tools: Preliminary sketches drawn by hand, coloring and finishing done by computer

Computer System Specifications:
Processor: Pentium 4 2.4C, Memory: 1GB, Video Card: ATI Radeon 7500, Hard disk size: 120GB, Display: Eizo T965, Software: Adobe Photoshop 5.5

Favorite artists: Manga artists: Tsukasa Hojo and Akira Miyashita, Illustrators: Yoshiyuki Sadamoto, Beksinski, and Akihiko Yoshida (*Vagrant Story* and *Final Fantasy Tactics* character design)

Work experience: Illustrations for the MMORPG *Tales Weaver*, character design and illustration for the FPS game *Archshade*, pinup illustration for *Magi-Cu Premium*

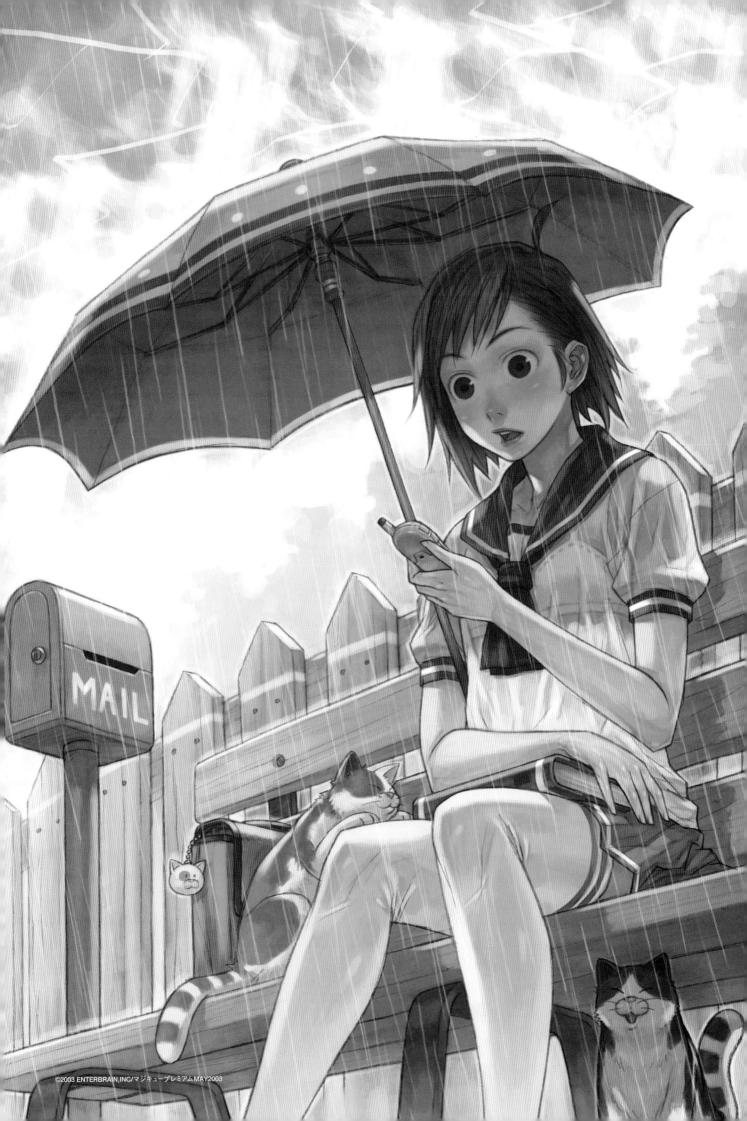

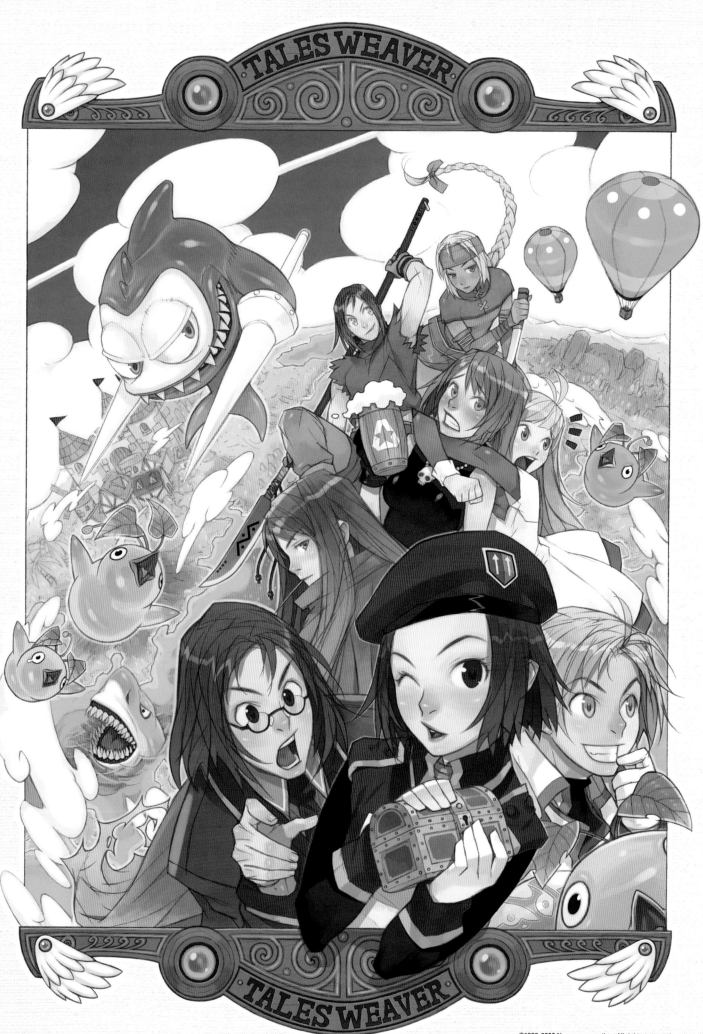

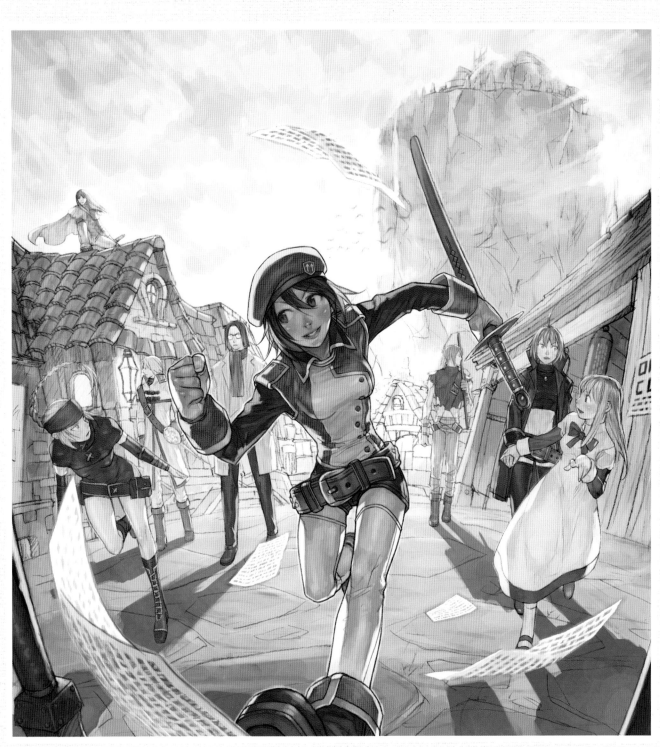

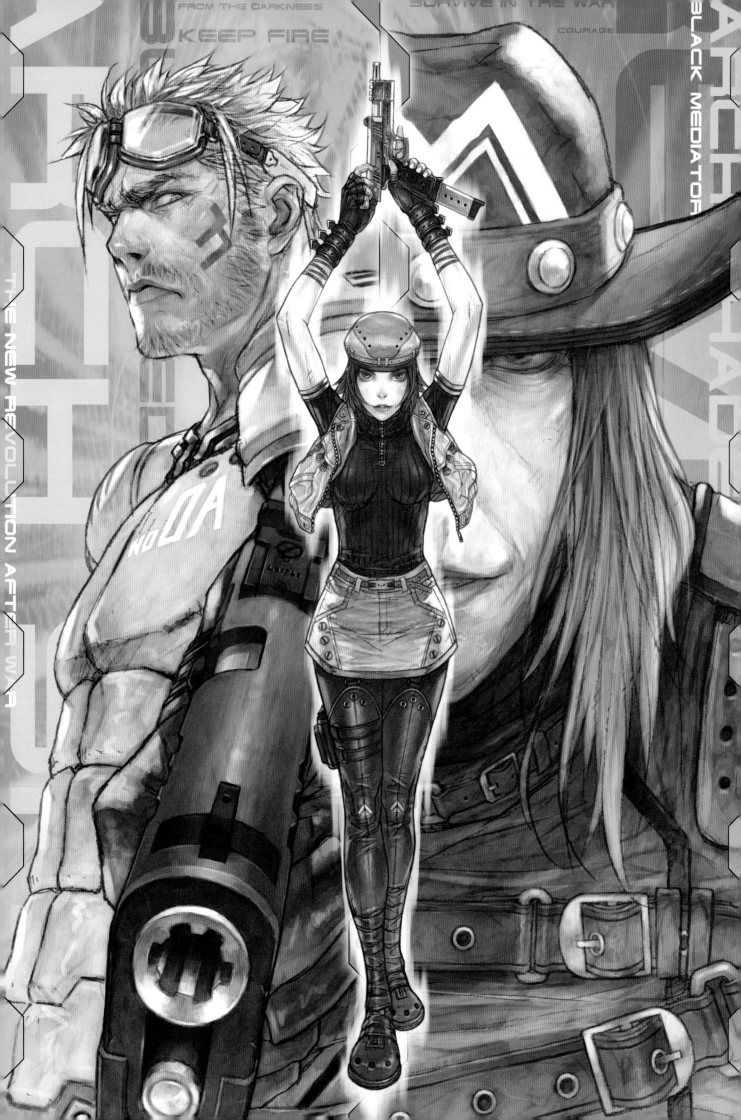

CHAENEY MAO
IN STUN PROJECT

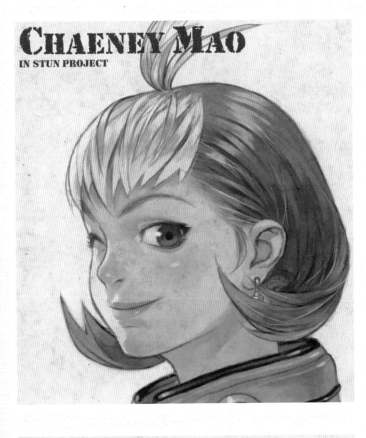

SEAN GRYSM
IN STUN PROJECT

ELLAN TURPENS
IN STUN PROJECT

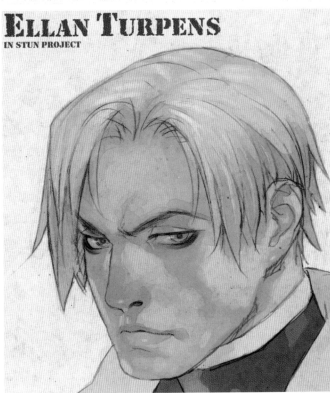

CARREY BETTENBERG
IN STUN PROJECT

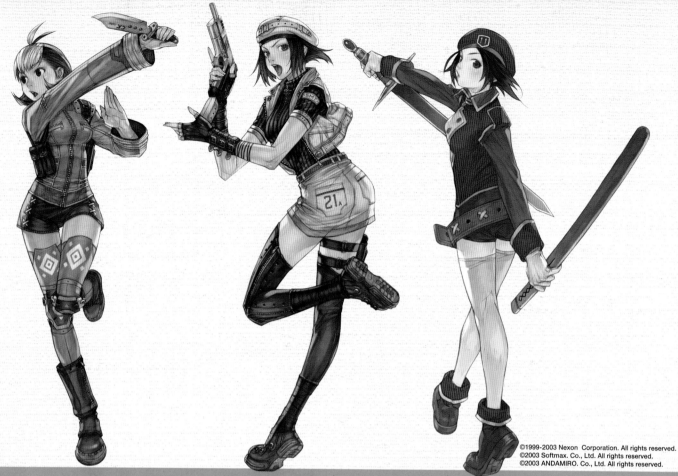

How I work

I traced pictures that were actually more like scribbles and turned them into these two monochromatic pictures. Sometimes, for fun, I scan in leftover rough sketches and do them over like this. The one to the right is of a woman in a bad mood shooting a gun. You can tell she's a good aim because the senior officer-type guy in the back is giving the thumb's up. The other image, below right, is of a guy who looks like a mercenary or an assassin and his daughter, amicably cleaning their guns together. Maybe it's because they live in a dangerous area that the kids are also taught how to handle a gun (you see this a lot in games). I had a good time drawing this.

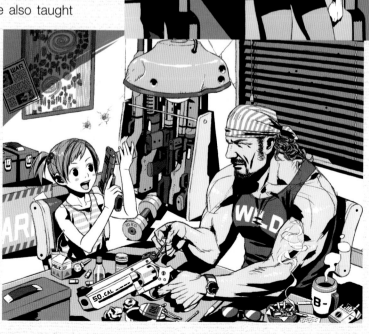

These are full-figure illustrations to be used for character introduction, cards, and other things. I was given a lot of freedom when doing the character designs. I don't care for clothes and weapons that are too futuristic; I happen to prefer a more contemporary look, which is why I dressed the characters this way.

Guide to Illustrations

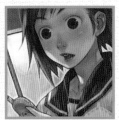

Untitled

This illustration appeared in Enterbrain's *Magi-Cu Premium* magazine. I remember being pretty tense while I was working on it because it was the first of my illustrations to appear in Japan. It's about a girl who gets all wet. I ended up drawing her sitting on a bench, looking at her cell phone. I added two cats for balance, because in this kind of situation a girl all by herself seemed too uninteresting. I had a little trouble with the picture because I seldom draw people or things that are wet. I guess this was one job that taught me there's always room for improvement. (p. 55)

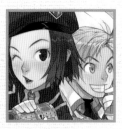

Tales Weaver

This is an illustration for the MMORPG *Tales Weaver*. They wanted pretty, sweet characters; I put quite a lot of effort into getting that effect. I did the picture in light colors to get the feel of a watercolor. It's only halfway what I intended, though. (p. 56)

Tales Weaver

This is another illustration for *Tales Weaver*. I'm pleased with the momentum the running girl projects. But now that I look at it again, I notice that I should have put a little more effort into the background. I won't worry about it; I'll just work harder next time. (p. 57)

Main poster of ARCH-SHADE

This is the main poster for the FPS (first person shooter) game *ARCH-SHADE*. I remember that I had originally thought of a scene that included lots of characters; then I had second thoughts about whether I would be able to get it done in time. I decided on a simpler composition: one of the girl characters with large images of two other characters behind her. After I finished the picture, I felt that I had overdone the color. (p. 58)

Illustration for character selector picture of ARCH-SHADE

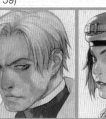

These pictures were used for the character selection screen. It's an FPS game, so they wanted a realistic feel. After the pictures were finished it seemed a waste to use them only for this purpose, so I did some basic editing and used them for several other things. (p. 59)

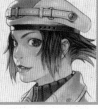

Craig Au Yeung

クレイグ・オウ・イェン

Lines that rise and fall breathe life into characters pulsating with energy. Striking colors and monochromatic simplicity are essential elements of stories seasoned with wit and irony. Au Yeung effortlessly blends artistic genres to create a world without boundaries.

In Hong Kong, Au Yeung is active as a manga artist, illustrator, graphic and interior designer, and art director working in multiple genres. Here is a taste of his work that springs from simple yet intriguing lines.

Personal Data

Birthday:	January 3, 1961
Birthplace:	Hong Kong
Gender:	male
Education:	The Hong Kong Polytechnic University (School of Design, BA in visual communication and Master of Philosophy)
Address:	No. 6117, General Post Office, Central, Hong Kong
Working tools:	Hand drawn and computer

Computer System Specifications: Power Mac G4 Software: Photoshop

Favorite artists: Italo Calvino (writer), Edward Gorey and Lorenzo Mattotti (comic artists), Federico Fellini and Michelangelo Antonioni (film directors), David Hockney and Derek Jarman (artists), Leonard Cohen (poet and singer)

Work experience: Art and image director for various pop artists; published more than 20 comic, fiction, and nonfiction books

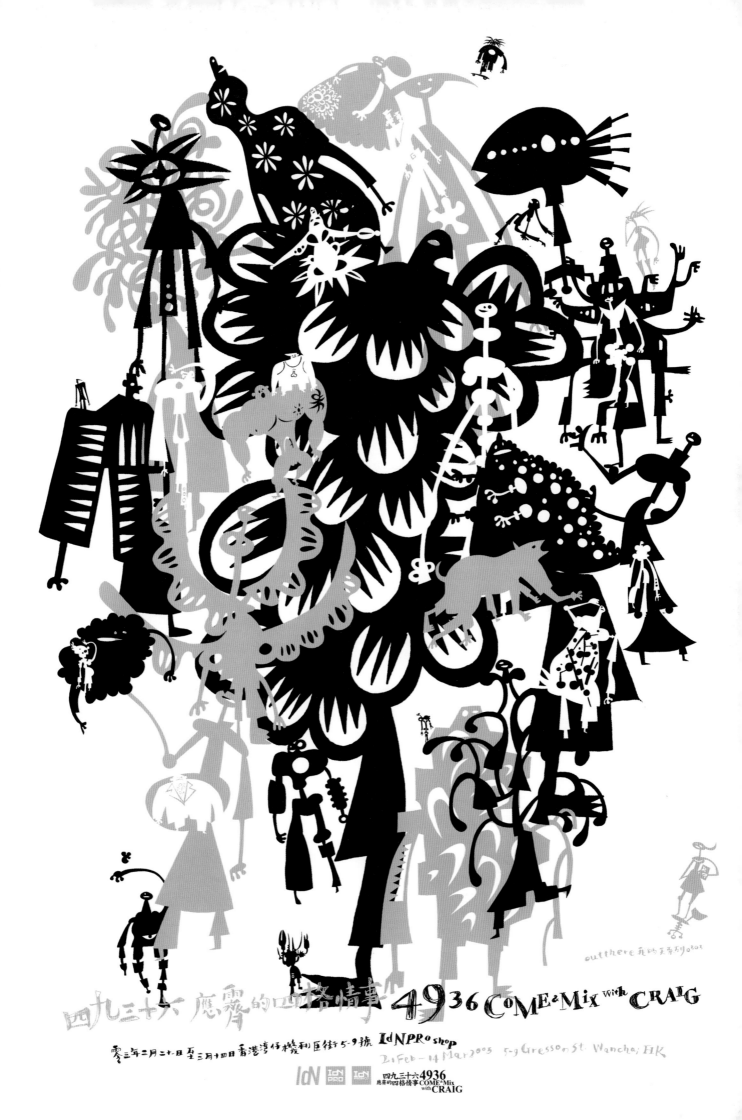

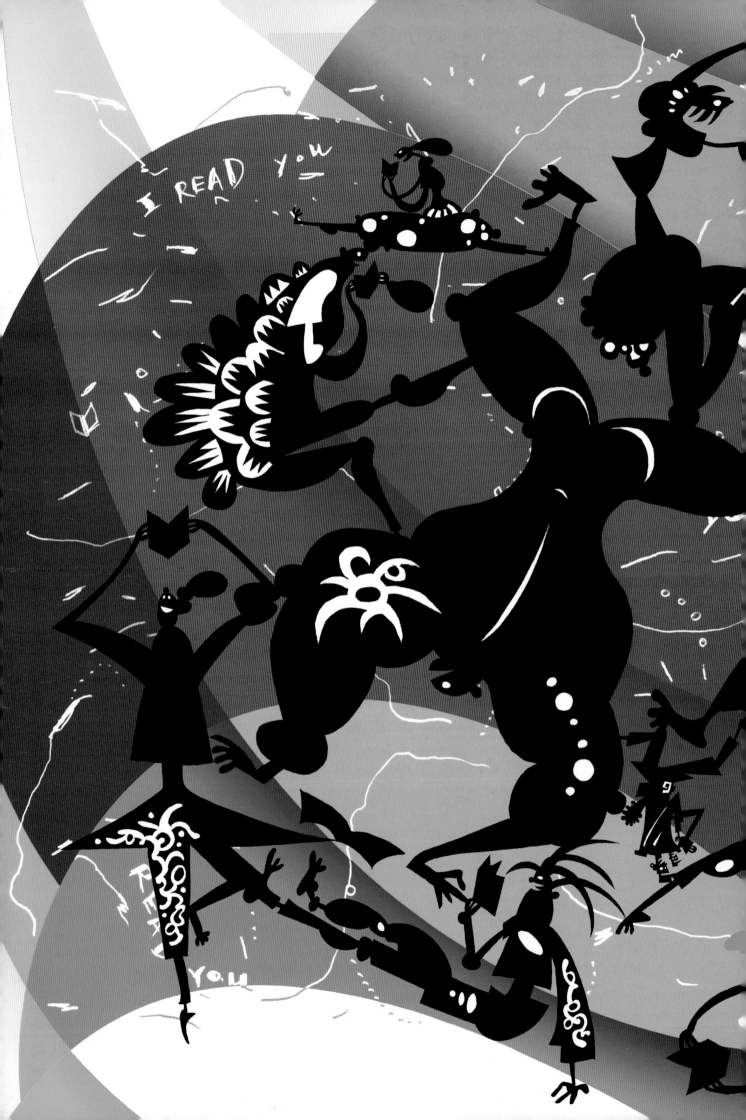

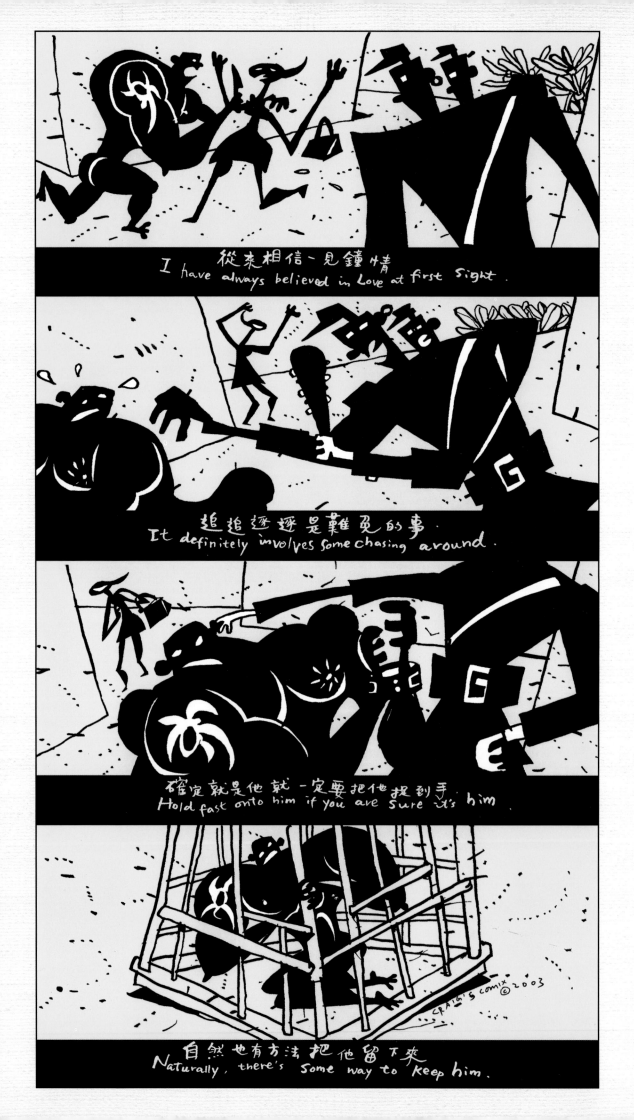

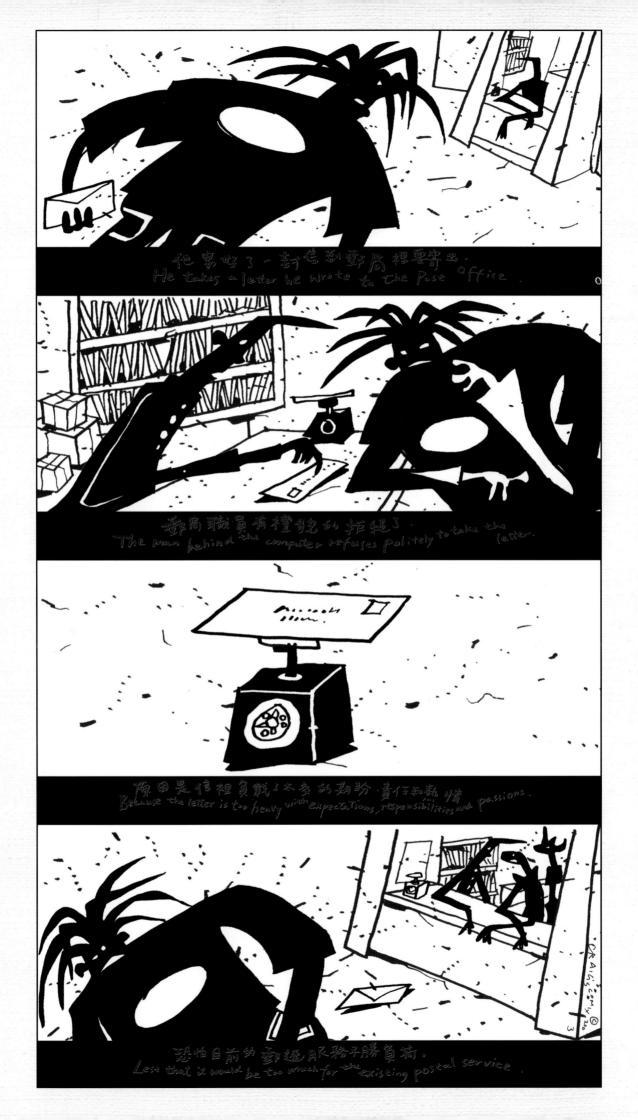

How I work

Q. Can you tell us about the characters who appear in your works?

A. From time to time I add new characters to my comix family—a boy surfing in uniform, a long-haired girl in a sexy dress—they are all products of times when I'm stressed out and discover a lot of energy in myself. Other characters are the tree by the harbor, a skyscraper, a bird turning into a machine, small people walking here and there...

Q. Where do your ideas come from?

A. I get ideas for scenes I illustrate by just looking out the window. Hong Kong is such a fascinating place—boring yet interesting, people on the move, and events taking place non-stop, 24 hours a day.

Q. What most interests you?

A. I'm a very sensitive person, so almost anything can arouse my interest, providing that I've gotten enough sleep and am not hungry.

Q. What's your technique for collecting images?

A. I'm continually making sketches of ideas that occur to me, either in my little notebook or on any piece of paper that happens to be lying around; sometimes I just draw for drawing's sake, with no intention of using it in some future work. But this accumulation of spur-of-the-moment drawings works better than if I deliberately set out to gather ideas. Eventually they all appear in my work.

Q. Do you use different methods to draw manga and illustrations?

A. Comics (comix) need a complete story line that develops content. Illustration, on the other hand, focuses on a single scene; it is very straightforward, conveying a single message.

Guide to Illustrations

NYORO

ニョロ

NYORO's images are drawn with a touch of the macabre. These detached, erotic characters, saturated in deep colors and showcased against elaborate backgrounds, dazzle the viewer.

NYORO's motifs include circular patterns and people without eyebrows. Her illustrations juxtapose sadism and sensuality in a detached yet forceful way. NYORO creates her unforgettable worlds with matte poster paints.

Personal Data

Birthday: May 9, 1978
Birthplace: Sendai, Miyagi Prefecture, Japan
Gender: Female
Education: Graphic design school
Homepage: THE NYORONO SHOW
http://nyorono.easter.ne.jp/
Working tools: Art materials and tools, poster paints (Nicker Designers Colors)
Favorite artists: Manga artists: The Nishioka brother and sister team, Ryoko Yamagishi, Hirohiko Araki
Musicians: Ningen Isu, Tokusatsu

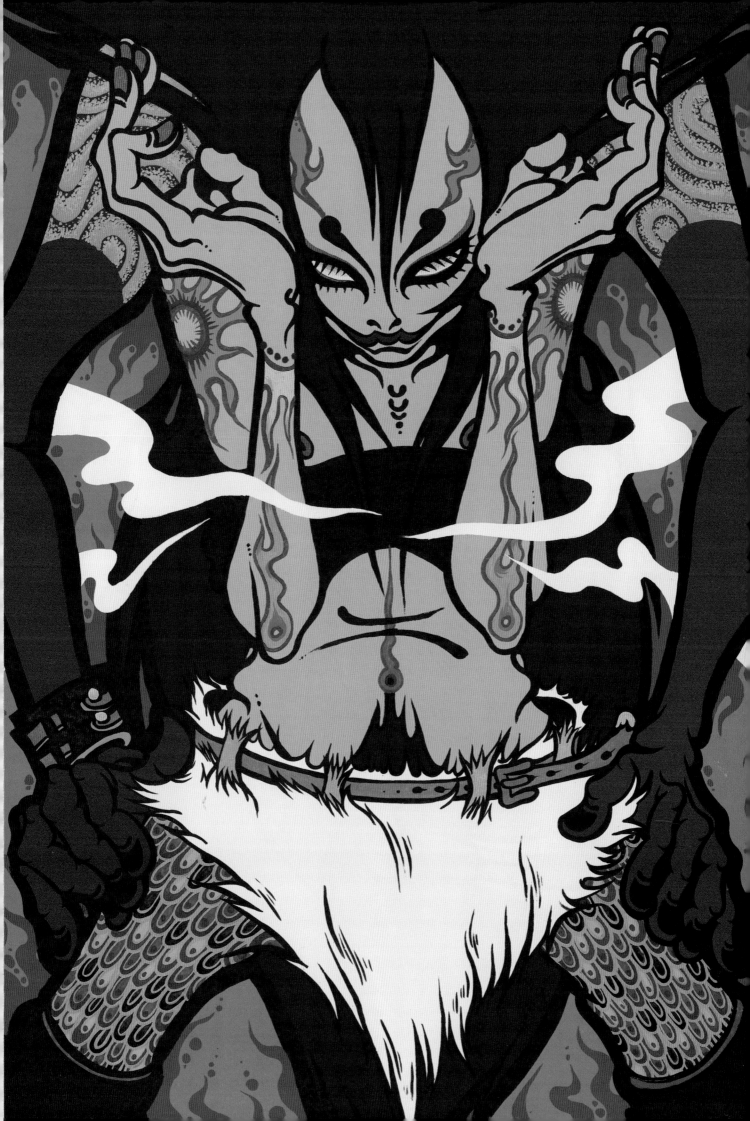

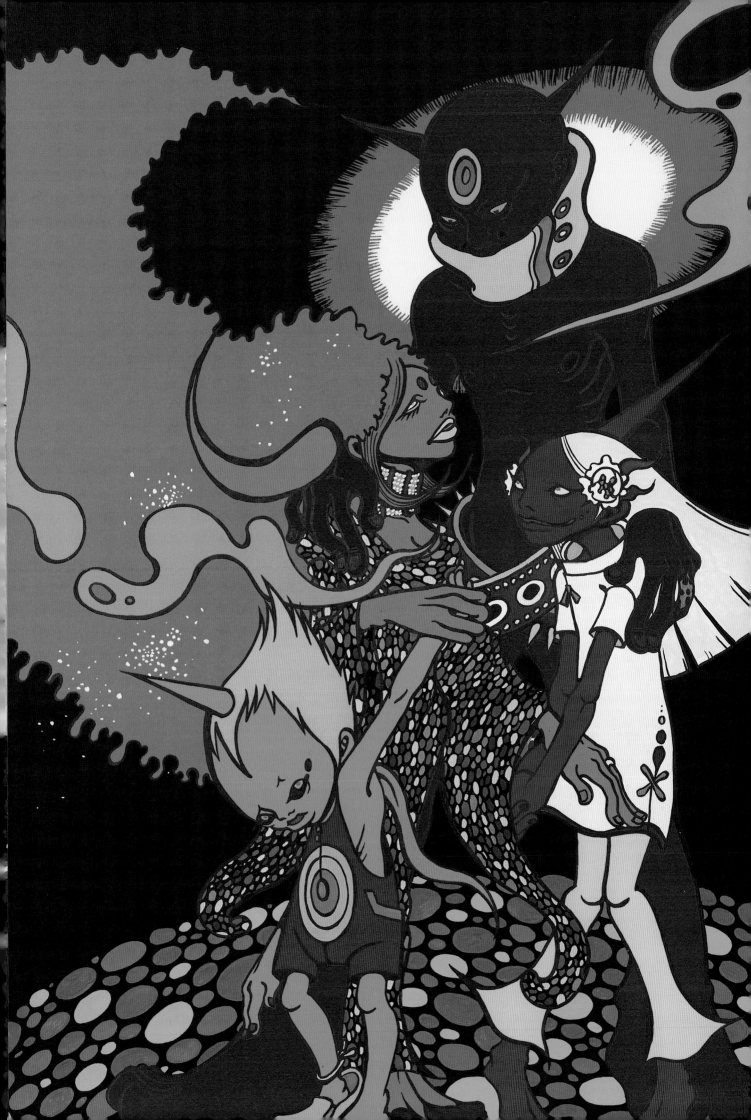

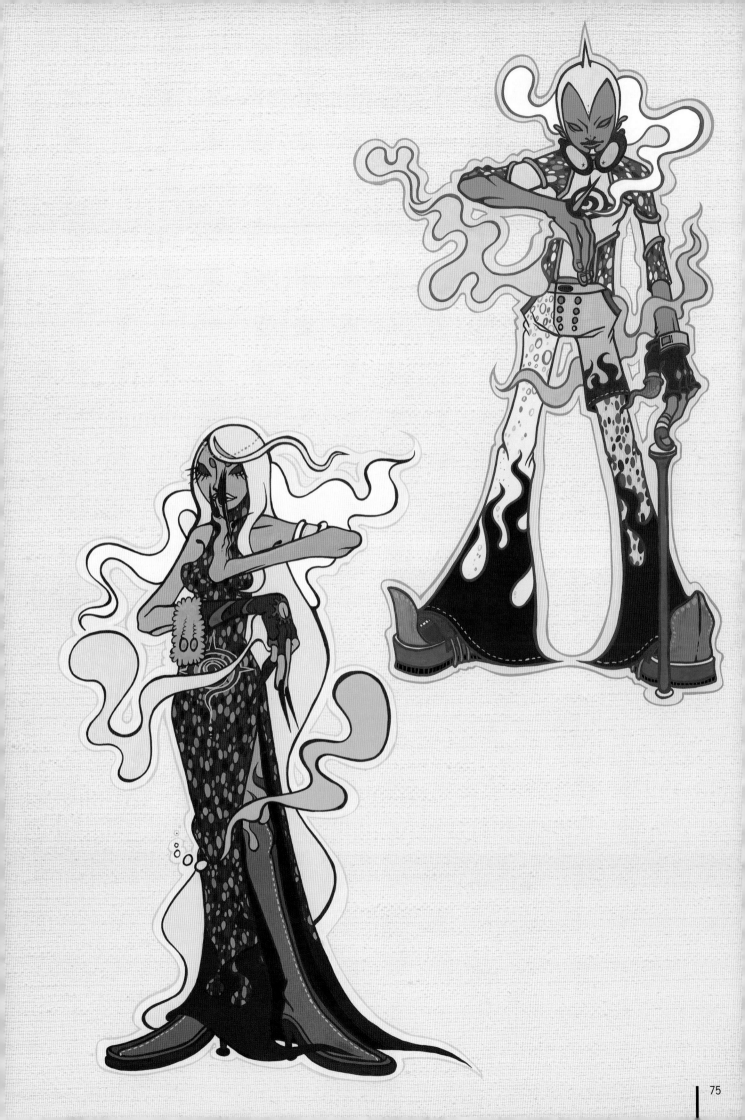

Step by Step

1 I normally do rough sketches on A5 or B5 paper. I'm not very good at right profiles, so I choose angles that are easy for me. The composition of the first sketch is too boring, so I tilt the picture, trace it, and add a few decorative touches. I want to give the composition a special twist, so I scan the sketch into my Mac and use Photoshop to flip things left and right. I'm pleased with the result so I enlarge the picture to A4 size, print it out, and trace it. That completes the preliminary sketch.

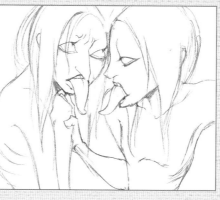 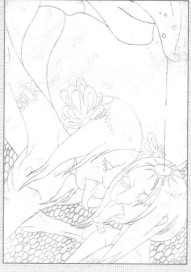

2 I use Nicker Designers Colors. I mix the colors to the consistency of a thick curry sauce and start painting areas of the picture at random, as colors occur to me. The color for the background came to me immediately—a mix of 556 Chartreuse and 504 Permanent Yellow—so I did it first. I don't think you always have to use skin color for the skin; here I painted it purple. I traced the main lines in pastel so I'm careful not to paint over them; that way they're easy to see when I paint the final lines. I mix 530 Royal Purple and 564 Shell for the skin of the character on the left, and add 527 Magenta to this color for the character on the right. Then I highlight the areas that are likely to be in the shade or the light.

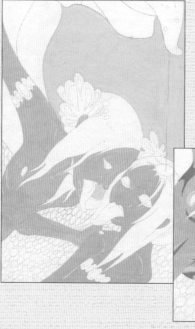 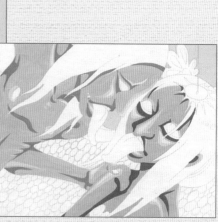

3 I use 516 Coral and 564 Shell for the hair of the character on the right and add 565 Cream Cheese to that color for the character on the left. I paint the skin of the character in back in a lighter shade to contrast with the hair of the characters in the foreground.

4 I paint the circles in the background pattern randomly, in 509 Mandarin Orange, 586 Mint Green, 569 Sunflower, and a blend of 586 Mint Green, 544 Peacock Green, and 564 Shell. This picture is done primarily in shades of pink and purple, so I paint the pattern in unexpected colors to tighten up the picture.

I outline the circles because it creates a nice effect even with an unlikely color combination. The outline color is a blend of 516 Coral, 520 Scarlet, 531 Wisteria, and 565 Cream Cheese.

5 I want to make the flower hair ornaments strong accents, so I paint them bright colors. To the basic mix of 544 Peacock Green, 541 Royal Blue, and 565 Cream Cheese, I add Royal Blue to get a darker shade and Cream Cheese to get a lighter shade for some of the petals. For the pattern in the flowers, I add 527 Magenta to the circle pattern outline color; using a color already in the picture as the base for a new color lends cohesiveness. I use 501 Lemon Yellow for the middle of the flower in the hair of the character on the right.

6 One's spirit is most potently expressed with the eyes, so I choose a color that will really stand out. I paint the tongue and nipples of the character on the left with the same color as the pattern in the flower ornament of the character on the right, and add 564 Shell to that color for the tongue of the character on the right. I paint the characters' teeth with Shell.

7 I mix 519 Maroon and 558 French Grey to put in the main outlines and bring the color scheme into focus. Because the flowers and arm patterns are accents, I outline them in a different color made by adding 516 Coral to the characters' outline color. I save some of the color I used for the characters' outlines so I can touch them up where the arm pattern color has run over. After I paint in the arm pattern it strikes me as a little sparse, so I improvise and add a little more to it. I outline the character in back in a less conspicuous shade—a mix of 516 Coral and 558 French Grey—so he doesn't overpower the characters in front.

8 The saliva dripping from the tongue of the character in back is important (the picture is called "Saliva") so I paint it carefully to look shiny and wet. Finally I paint in the petals around the heads of the characters to look wet like the saliva.

9 I check the overall balance of the picture. It seems to need something more, so I paint flowers in the bare spots. I always put fixative on a picture because it subdues the colors somewhat. I take another look at the overall balance; it's good, so the picture is finished!

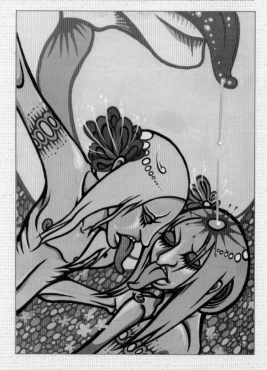

Lizard

I drew this on a piece of leftover pasteboard I had at home. Because I used opaque poster colors, I didn't think the surface of the pasteboard would have any effect on the picture. It turned out to show through a bit, though, which created a different look. This was a new discovery for me. In this picture I made lavish use of colors I don't particularly care for. Every so often I paint with colors I don't like and I make interesting discoveries. (p. 71)

Angel wings

Once, when I participated in a street fair, a child walking by pointed to this picture and said, "Mommy, that picture's scary; there's blood running out of it." It wasn't blood, just a design. Anyway, that child kept sneaking back to look at the picture. That's what I try to achieve—pictures that shock viewers or that, for some inexplicable reason, they can't seem to get off their mind. (p. 72)

Enjoyable kindergarten

The flame pattern around the character's eyes is similar to how I used to do my own eye makeup at the time I drew this picture. Of course, it's much more overstated than mine was. (p. 73)

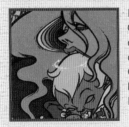

Rice ball

One day my friends and their children came over to see me and I used the children as models for this picture. Children smell like milk, so they seem like they'd be good to eat—sometimes I'm tempted to take a bite. (p. 73)

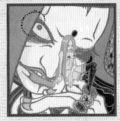

Ring

I like the colors in this picture, particularly the ones I used for the hair and circle pattern. (p. 73)

The Onihei family

This is an illustration of Onihei, who is one of my characters. I like drawing imaginary characters like this ogre, because you can do them any way you want to. This picture was fun to draw, so it took much less time than the others. The blue ogre in front turned out really cute and I'm entirely satisfied. (p. 74)

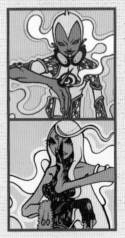

Man & woman

These illustrations were done for T-shirts. The two make a set; the man was printed on the left side and the woman on the right side. They were pretty popular. I made the characters look tough so they wouldn't wilt in the summer heat. (p. 75)

Kon-Shu

コン・シウ

Kon-Shu's characters live in cyberspace. These high-spirited girls, set against schematic backgrounds, project a natural and unsophisticated sexuality that entrances the viewer.

Kon-Shu likes to draw girls with appealing expressions calculated to evoke a sympathetic response. Like the manga he creates, his illustrations aim to convey the character's story or activity. The girls are impressive attired in their futuristic costumes, but there are also many stories about them, set in the present, that aren't on the Web site.

Personal Data

Birthday: October 15, 1974
Birthplace: Okayama Prefecture; currently resides in Setagaya-ku, Tokyo.
Gender: Male
Education: Okayama Hosen Senior High School (left Shibaura Institute of Technology before graduation)
Homepage: S.D. Labo P-kohan, http://www.din.or.jp/~konshu/
Address: konshu@din.or.jp
Working tools: Drawn by hand and computer (so far not a combination of both)
Art materials and tools: Dr. Grip and drafting pens for rough sketches; Zebra G-pens and Pilot drafting ink for final lines; bond paper, Kent paper, manga manuscript paper, and copy paper; Copic markers, acrylic gouache colors, and poster paints for coloring.
Computer System Specifications: Handmade Dos/V computer (Operating System: Windows NT 4.0, Memory: 512MB, Processor: Celeron 300 MHz, Hard disk size: 20GB, Software: Photoshop 4.0-5.5)
Favorite artists: Range Murata, Kunihiko Tanaka, Nishieda, Koji Ogata, Takehito Harada, Yuji Iwahara, Shinya Kaneko, Sakura Takeuchi, Tagro, Kuniyuki Sugawara, Akari Funato, Kouhei Kadono, Hideyuki Kikuchi, Anne McCaffrey, Rembrandt, Mucha, Minoru Sashida, Noriyuki Makihara, Suga Shikao.
Work experience: Illustration and manga

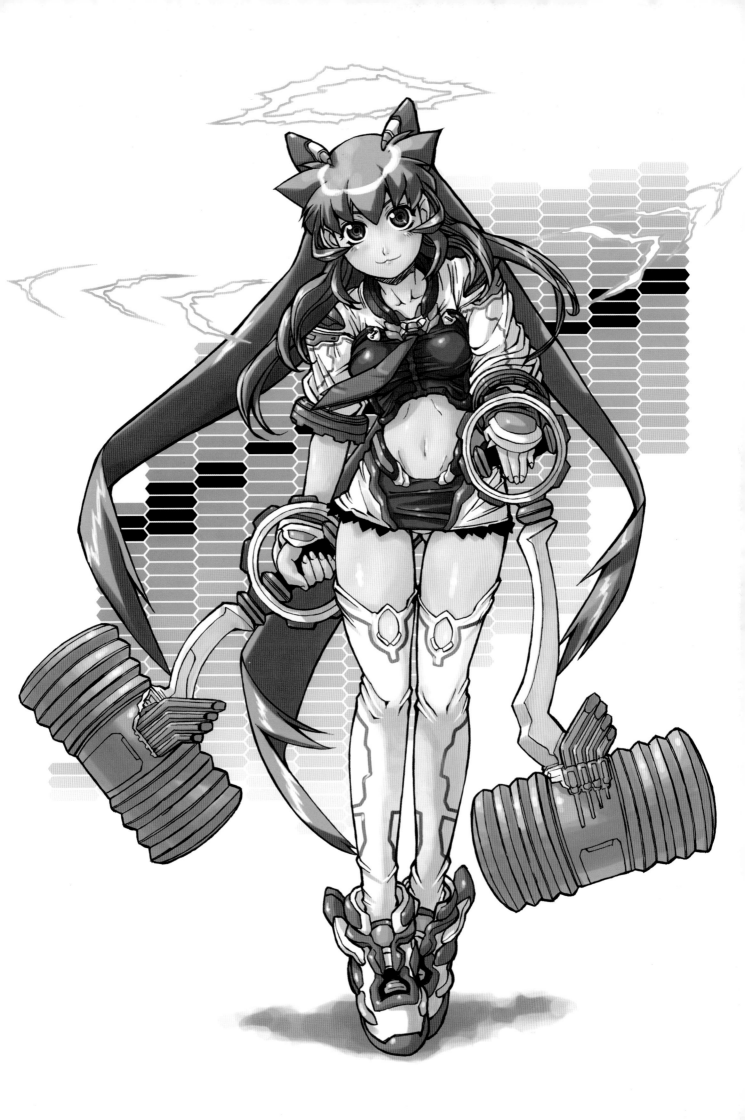

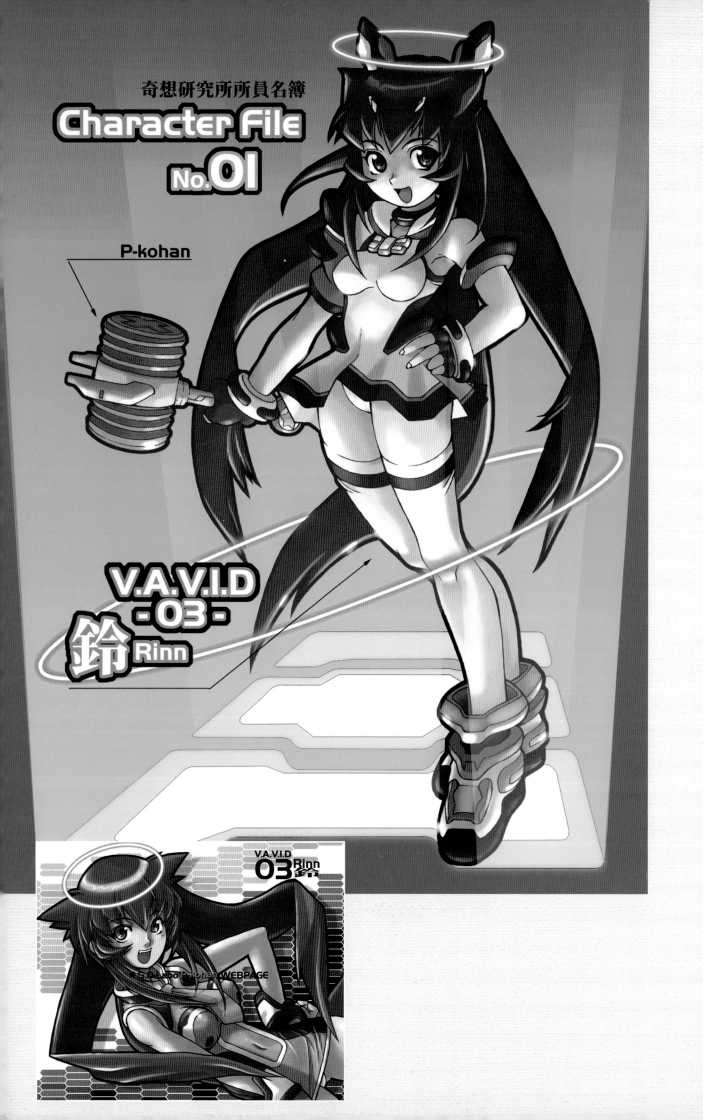

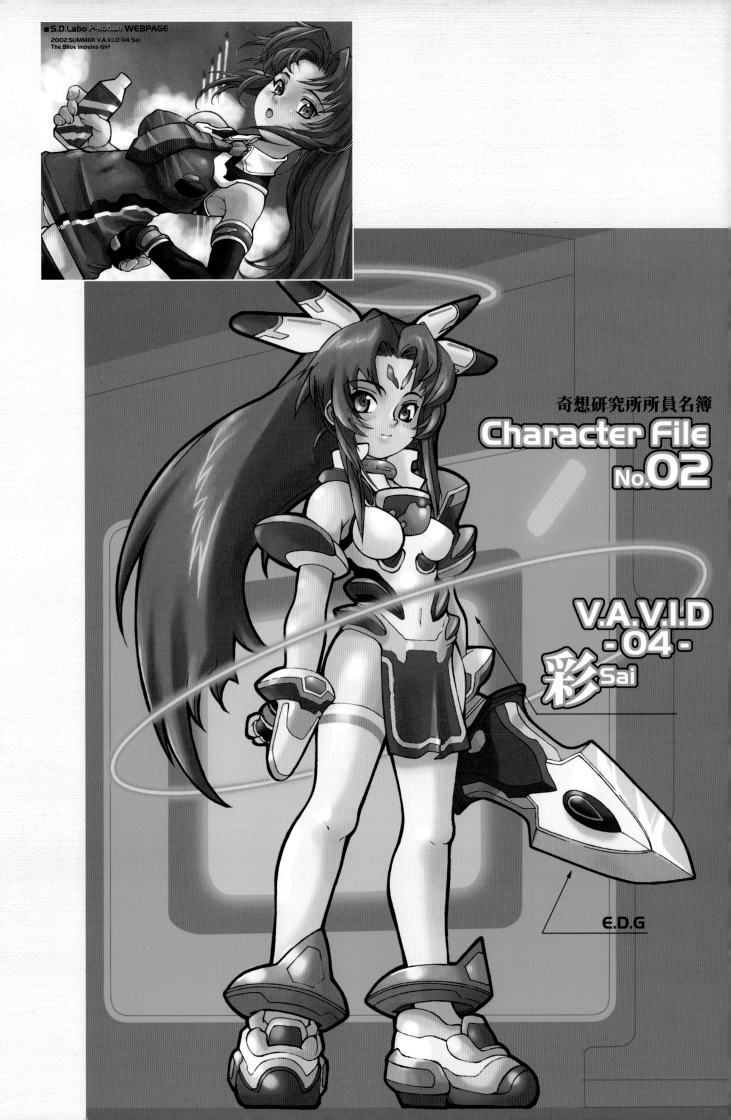

奇想研究所所員名簿

Character File
No.02

V.A.V.I.D
-04-
彩 Sai

E.D.G

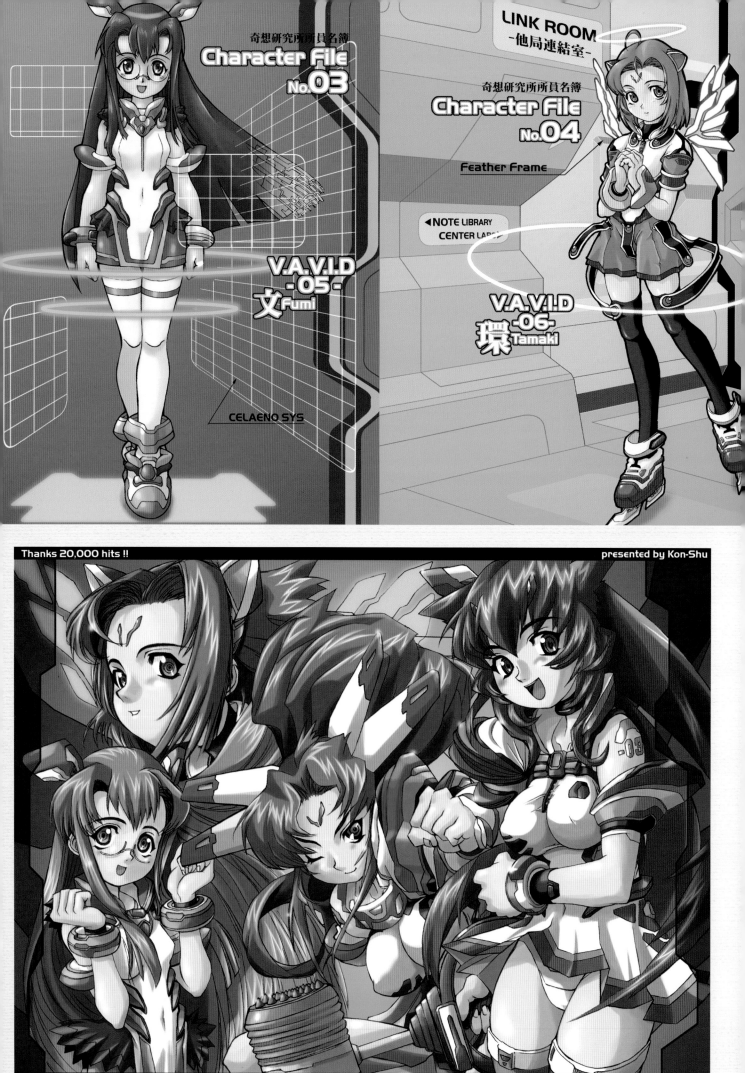

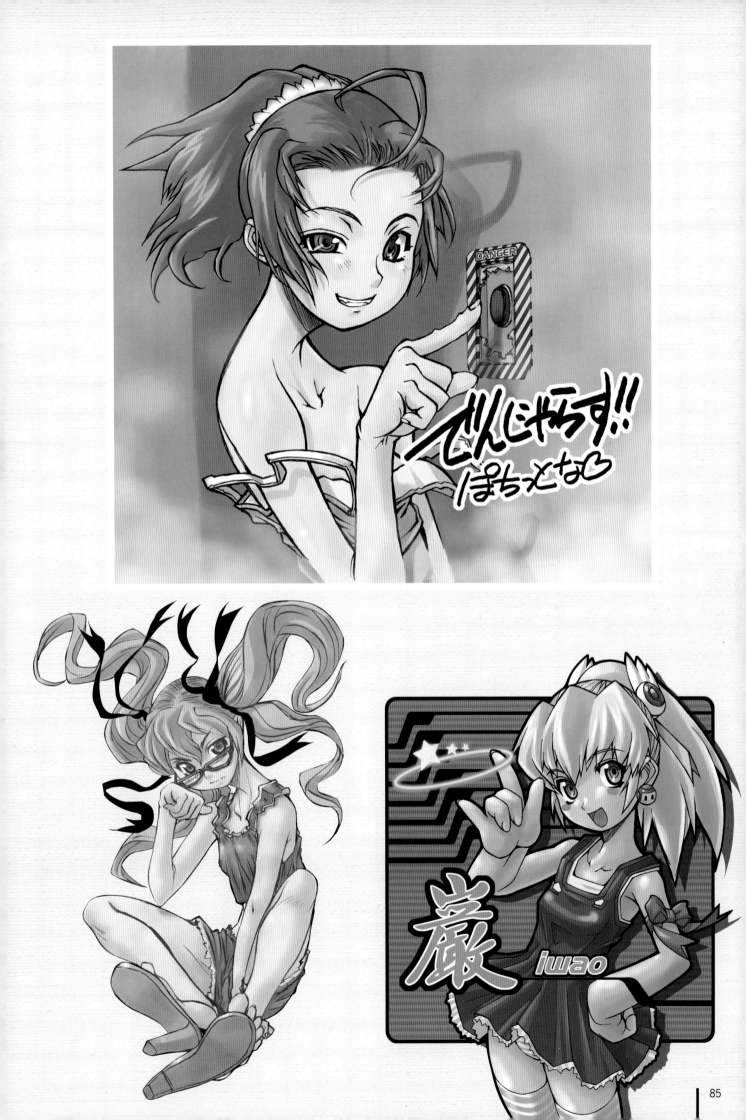

でんじゃらす!!
ぽちっとな❤

巌
iwao

How I work

I don't always draw these four characters in science fiction costumes; sometimes I put everyday clothes on them. I had a backstage dressing room in mind when I did this sketch. After a day's work as site guides, they change into clothes they can relax in.

About once every six months or so I get tired of looking at the costumes, so I'm always fiddling around with them. I usually do this behind the scenes, and only a few make it to the site. Anyway, the girls are underdressed.

Here's a boy, for a change. When I'm thinking up manga stories, I usually imagine the hero as a young boy, although those stories almost never get made. It's really too bad.

Right now I'm into girls who do their hair in pigtails, and I've been drawing lots of them. When I go on one of these binges, I discover a new side of myself that allows me to expand my artistic range.

Guide to Illustrations

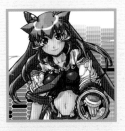

Rinn
These are my most recent color illustrations. I change main character designs over and over; in this case, the changes were radical—composition and proportions. I wonder why I did that?! (p. 81)

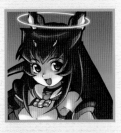

Rinn
You might say Rinn is one of the guides to my Web site; she adds the extra touch. Rinn is the easiest to draw; I designed the character and facial expressions to be easy to manipulate. But recently she's begun to think for herself. (p. 82)

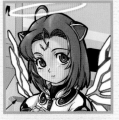

Sai
I designed the character named Sai to be a site guide like Rinn. I put her in charge of the graphics page. She was born after Rinn, but she's much more grown-up, cool and composed. (p. 83)

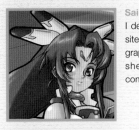

Fumi
I had a quiet, bookworm type in mind when I designed Fumi, who is the guide to the text page on the site. Her distinguishing feature is her glasses—standard for bookworms. Her two big sisters are opposites in personality, so she's always stuck in the middle with the unenviable job of trying to keep the peace. (p. 84)

Tamaki
The last of the four characters, Tamaki is in charge of the links page. She looks the youngest and isn't as good a communicator as her big sisters. I think they use their hammer, sword, hair, and wings to create and operate the site. (p. 84)

Girl about to Push a Button
There is an old saying in Japan that everyone has a secret button, but you should never push it. No, that's a lie. I like the determined look on the character's face. (p. 85)

Glasses and Pink Sandals
Sometimes when I'm just doodling, I'll come up with an idea and a character takes shape. What if the character's ribbons resembled snakes; then she'd be something like the mythical Medusa. She's not at all scary, though. (p. 85)

Iwao, Roll from Rockman
I draw a lot of characters that other people have created, but I have a warped personality that prompts me to change the images to suit myself. Some of them end up being unrecognizable. (p. 85)

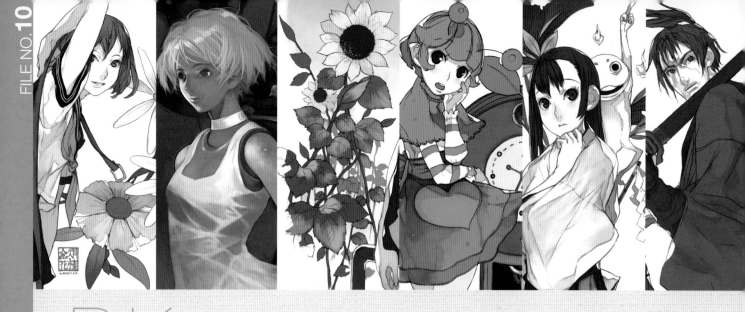

D.K

ディ・ケイ

Lovely girls illustrated in delicate colors. Robots with amazing shapes and intricate mechanical detail. Two completely different types of characters from the same hand play opposite each other. Check them out!

D.K is active in several genres, including cover illustration for novels and character and mecha (mechanical robot) design for movies and anime. D.K is one of those rare artists who creates both attractive, stylish human characters and surrealistic fantastic mecha. Many of the illustrations in the collection introduced here were done for the planning stages of various projects. We hope you'll enjoy them.

Personal Data

Birthday: October 13, 1978
Birthplace: Hachioji, Tokyo, Japan
Gender: I'm not telling.
Education: High school
Homepage: FLOWER
http://mypage.naver.co.jp/flowerss/
Address: discking@mrj.biglobe.ne.jp
Working tools: Computer System Specifications:
Processor: Pentium 4 2GHz, Memory: 1GB Software: Windows 2000
Hard disk size: 60G
Favorite Artists: Shotaro Ishinomori, Osamu Tezuka
Work experience: Character design for anime and games, mecha design for the movie Casshern, character design for the game *Red Ninja*, cover art for *Umi no Ue wa Itsumo Hare* (It's always sunny out at sea) by Shinkuro Bando and Toru Takasaki (Mediafactory Inc.), cover art for *Kamisama no Pazuru* (God's puzzle) by Shinji Enomoto (Kadokawa Haruki Corporation)

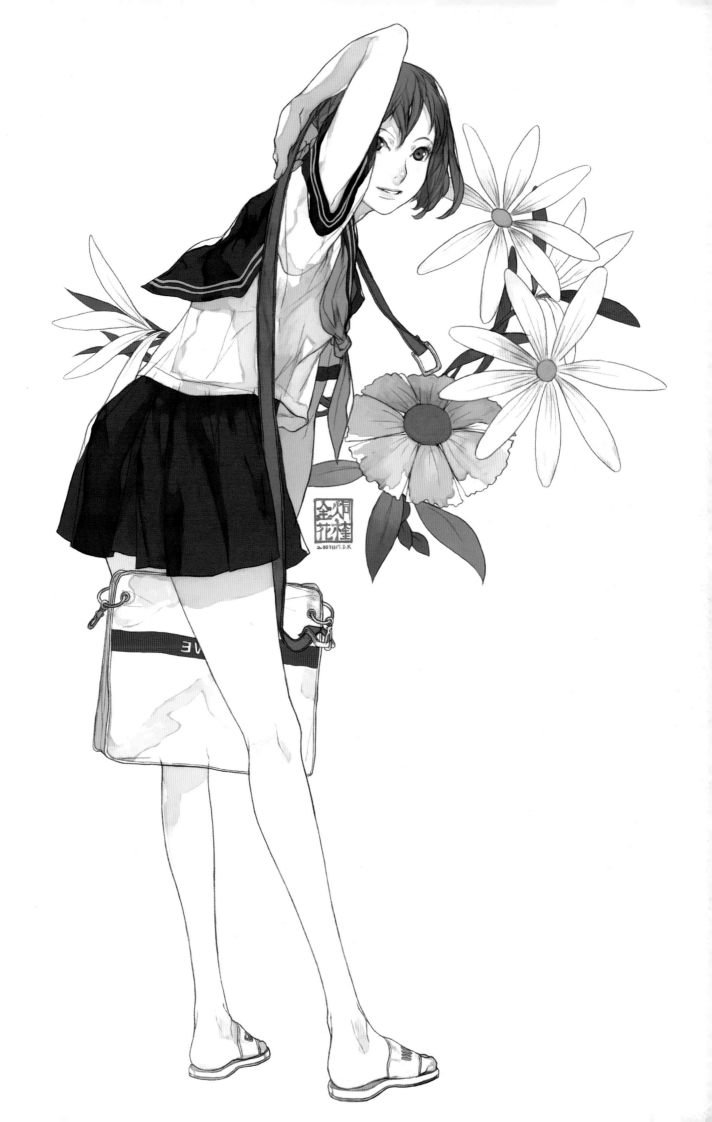

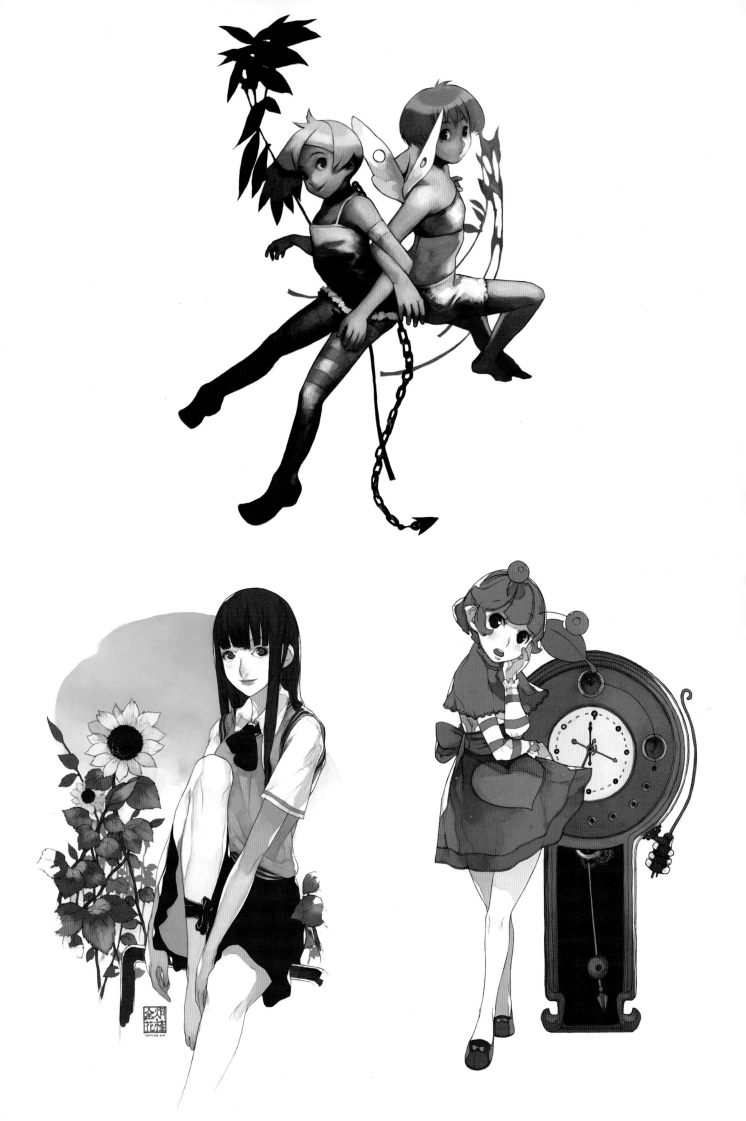

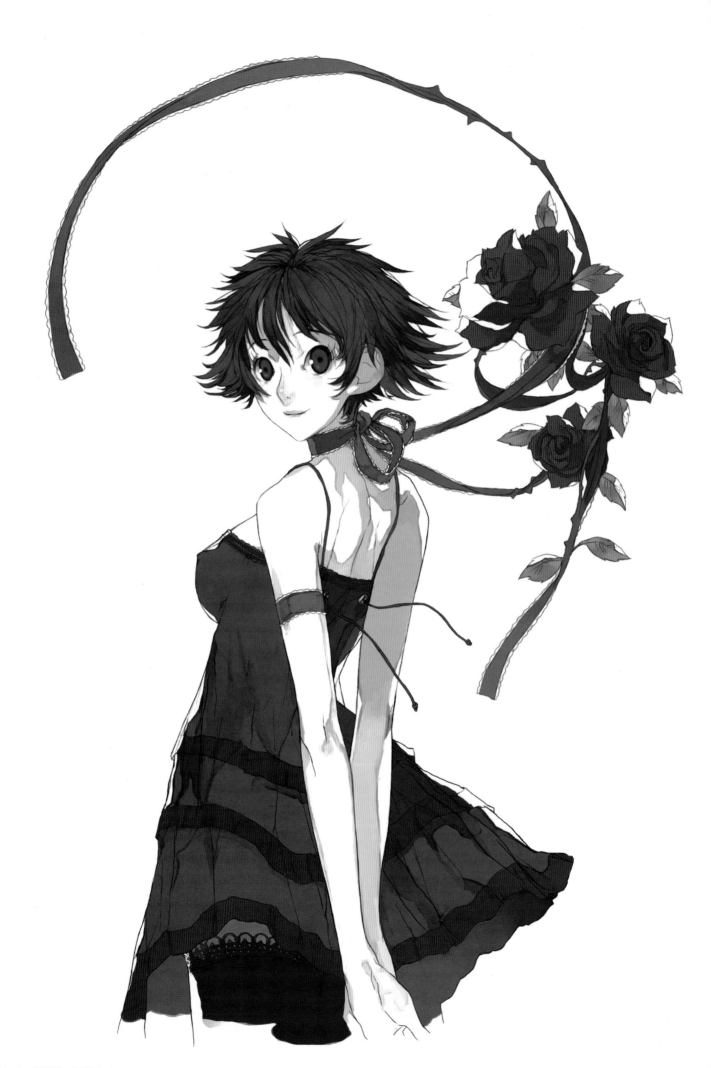

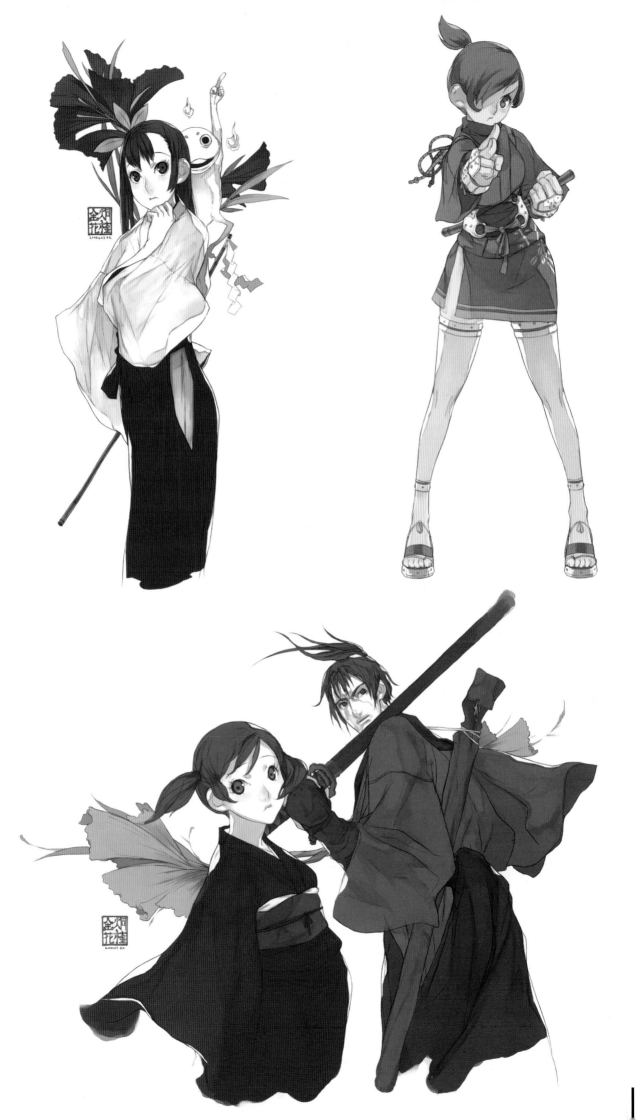

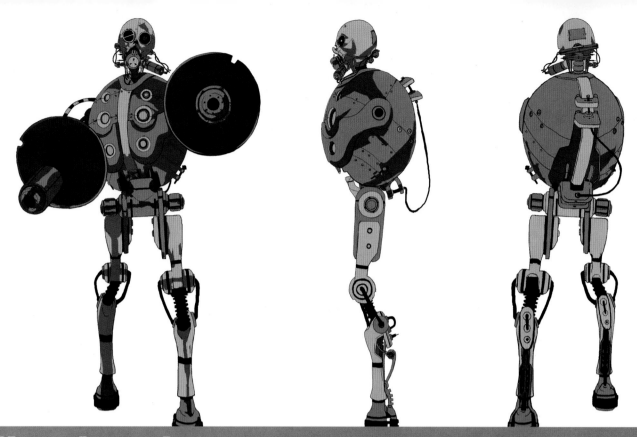

How I work

My job is to design mecha and monsters, and I work really hard at it. Those are the sad creatures who get zapped, so to speak, in anime and the movies. But I love them! I don't like drawing humans. I'm not all that good at mecha and monsters, either, but I love my work. Since I was a kid I've loved science fiction and heroes that transform into something else, so I'm really happy to be doing this work. I have to draw orthogonal projections and stuff, but I love it so I work hard at it. Once in a while I get the configurations wrong and I have to do it over again, but that's fun, too. I put a lot of effort into drawing the boss monsters, but I can create the little guys much faster. Whenever you watch a movie or anime with monsters and mecha that get fried right away, remember that there's someone who's busy designing those guys.

They're fun…they're a hundred times more fun than girls.
But…in some ways…I like drawing girls.

Casshern, an anime that I liked as a kid, has been made into a movie. It was just by chance that a year ago I got to participate in that project as a mecha designer. I didn't want to change the image of the robots I remember watching as a kid. It was tough to design new ones and preserve the appearance of those 1970s robots I loved, but I managed it somehow. That was the first job I had as a mecha designer. Now I design lots of anime mecha and monsters, but these two mecha designs (see top of page) are ones I will always remember. If you get a chance to see this movie in America, I hope you root for these two, even if they get annihilated by the hero.

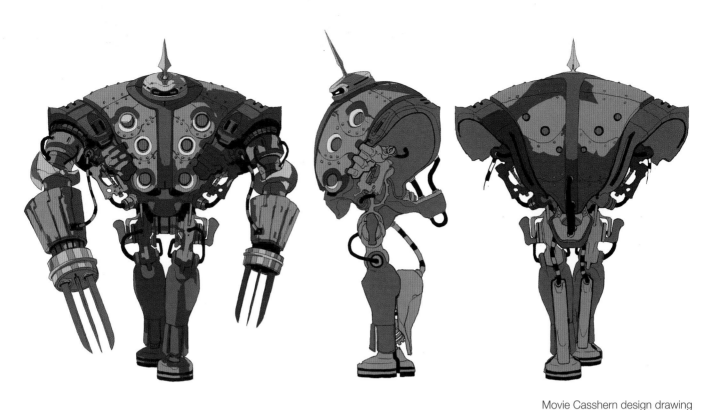

Guide to Illustrations

Flowers

The coloring in this picture is...how can I explain it?...a product of my inability to really focus and get it exactly right. It was just used for planning, so I guess it's good enough. I don't really like drawing girls very much, but for some reason my life seems more and more taken up with drawing only girls, or is it just my imagination? Asking someone who draws monsters for a living to draw girls is terrible...it's too terrible! (p. 89)

error

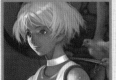

This brings back a horrible memory. If you look carefully, you'll see that one of the bird's wings is missing. The day I drew this, my friend had a fight with his girlfriend. He called me and started talking about how he wanted to die. To stop him from doing something crazy like committing suicide, I drank with him up until two hours before the deadline for this picture, then I worked on this and sent it off. When the book came out and I saw it, it was me who cried, remembering that sad day. There were two birds but only three wings. (p. 90)

Summer

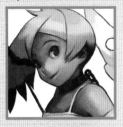

This is an old picture I did in the summer of 2001. These are characters I intended for manga. There were girls in the story, but lots of monsters, too. The problem was that I had never drawn cute monsters before. I couldn't keep doing it, so I gave up on the story. But I'm the kind that thinks zombies are cute. Really! (p. 91)

Flowers

It was winter, but I drew a summer picture. Winter is lonely, and my lips freeze. I console myself with the thought that summer will come again...but I hate summer. Japan in summer is no place for human beings. It's hot, hotter, burning hot. But I manage to stay alive in the summer and draw. I guess winter isn't so bad after all. (p. 91)

Clock

To tell the truth, it wasn't my idea to create this illustration of a pretty girl, but my customer insisted upon it. They thought I might enjoy painting this. I'm not sure about this, though. . . (p. 91)

Windy

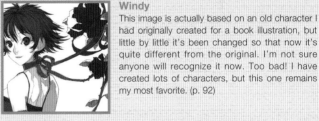

This image is actually based on an old character I had originally created for a book illustration, but little by little it's been changed so that now it's quite different from the original. I'm not sure anyone will recognize it now. Too bad! I have created lots of characters, but this one remains my most favorite. (p. 92)

Miko

I painted this for a 2004 New Year's Card for the company that employs me. They asked me not to paint a ghost or a spook, as it's too scary for the New Year. That's why I made this so pretty and colorful. Anyway, I like painting Miko (which means a shrine maiden). (p. 93)

Hiding

I've worked on this game for two years, so by now I'm used to drawing kimonos, ninja, and samurai. I thought it was going to be a game that had lots of traditional Japanese ghosts and apparitions, which is like drawing monsters. But all I had to draw were girl ninjas in kimonos. I was pretty resentful; still, nobody can draw ninjas and samurai as effortlessly as I can. (p. 93)

Fighting the Ogre

This picture is a present I did for the American staff. It's the original concept I had for Red Ninja...it's a much different game now, of course. That was my first job, so I didn't know how to approach the work or anything else. It was tough and lots of times I was ready to quit. But thanks to the Japanese director, I've gotten this far. The director told me I shouldn't forget that it's because of the American staff that this game got made. I'm going to do new Red Ninja pictures that make up for the dismal work I did two years ago, but first I'd like to thank all of you on the American staff for everything you've done so far. I've consented to my illustrations appearing in this book, even though I still didn't do a very good job, in the hope that someone on the American staff will buy this book and see my message. If that happens, wouldn't it be a romantic story! Red Ninja isn't finished. I'll keep doing my best here in Japan! (p. 93)

AYARA

アヤラ

AYARA's girls dream sweet dreams surrounded by delightful objects. For these girls, candies, cakes, and toys are magical items. But their expressions of ennui clash with their colorful surroundings; they know such lovely times will not last forever.

AYARA loves pink. She also makes ample use of black cats, confections, and playing cards. Stripes and other eye-catching designs in the background and on clothing are essential elements of this candy-colored world that is uniquely hers. Although the pictures are drawn digitally, AYARA's personality is reflected in her charming characters, and the illustrations project the warmth of matte colors.

Personal Data

Birthday: April 14
Birthplace: Hokkaido, Japan
Gender: Female
Education: Professional art school
Homepage: LuLu Pic,
http://www.ne.jp/asahi/tetora/lulu/
Address: tetora@piano.email.ne.jp
Working tools:
Computer System Specifications:
Macintosh G4 Operating System: Mac OS 9, Memory:
512MB, Software: Photoshop 5.5
Favorite artists: Akihiko Yoshida, Aya Takano
Awards: Honorable Mention in the 5th Enterbrain
Entertainment Awards (2003)

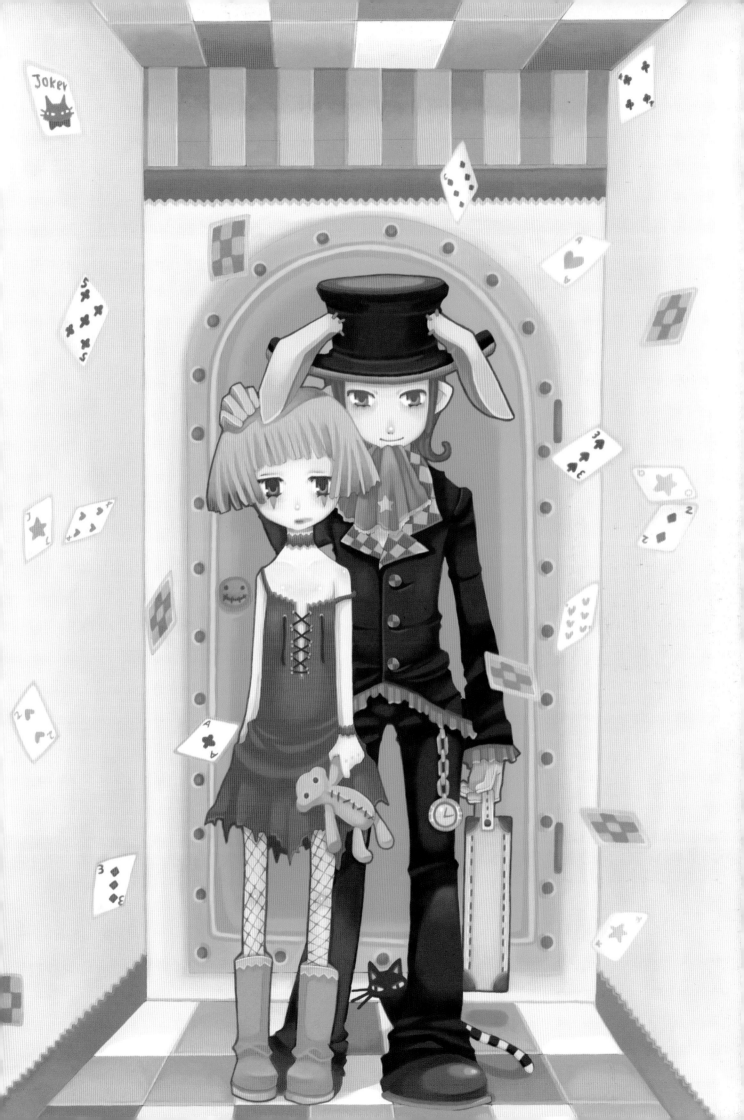

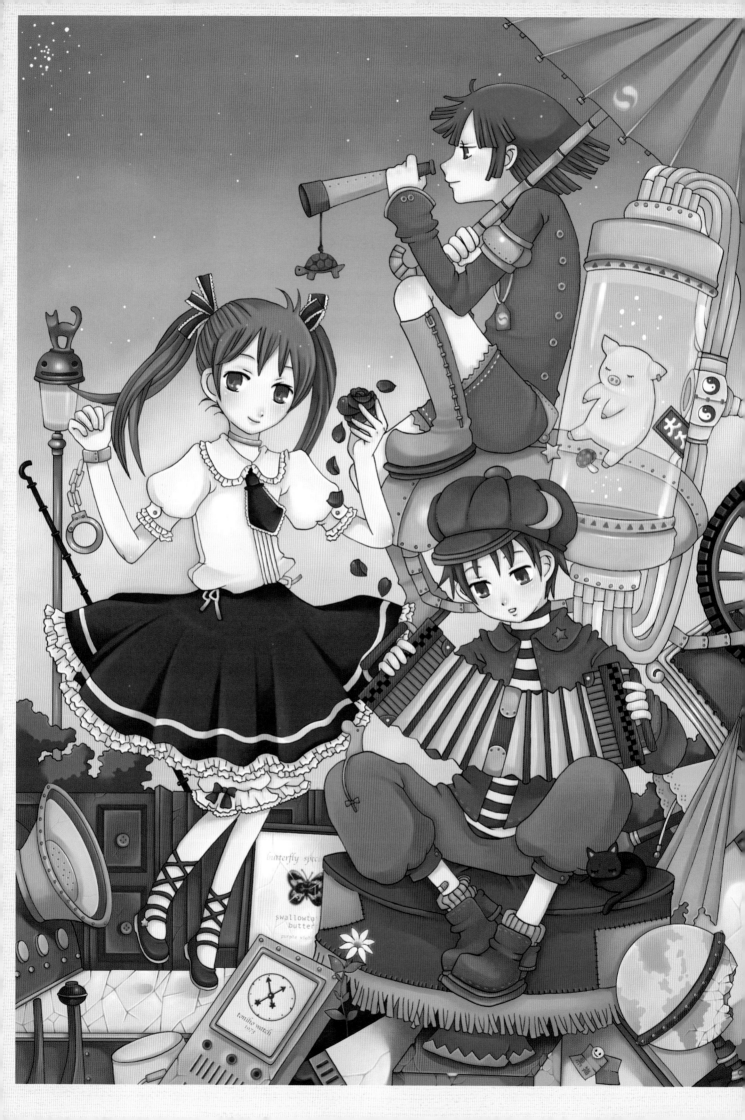

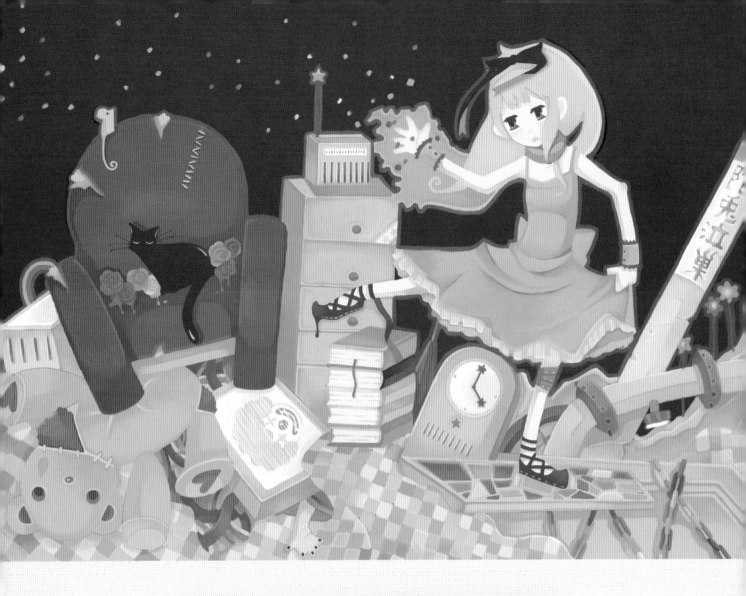

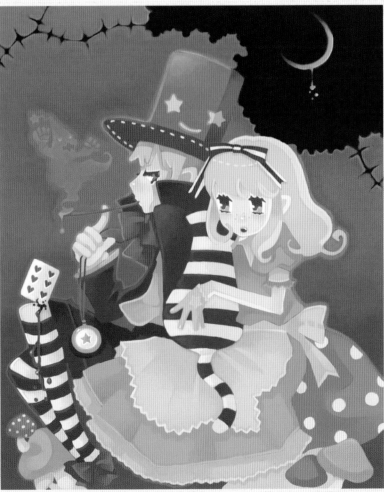

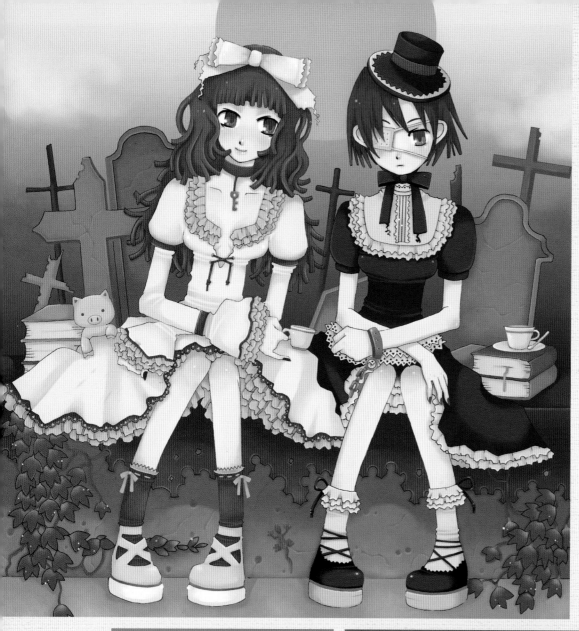

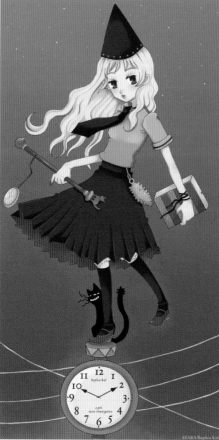

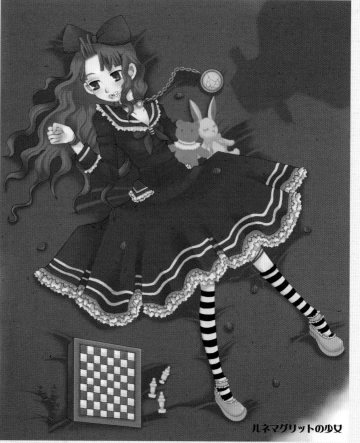

ルネマグリットの少女

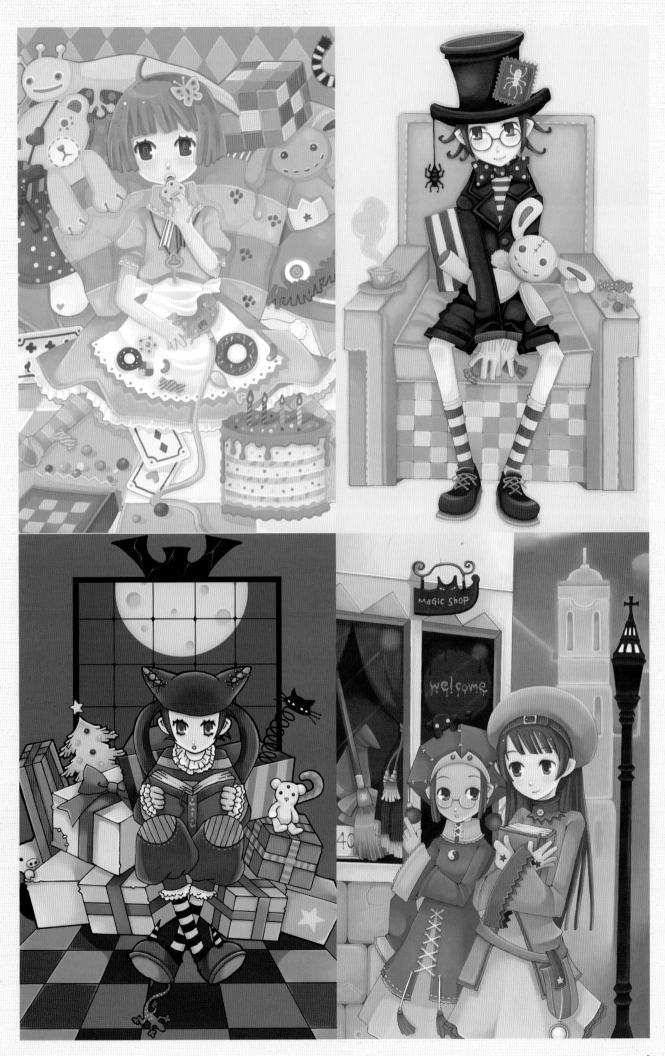

Step by Step

1 I scan in the line drawing and save it as a layer. Then I make new layers under it for the face, hair, clothes, small objects, and background in that order. I make two layers for each element—one for rough painting to check the color scheme, and one for final painting. First I paint the girl. I paint the hair by layering dark yellow to get a 3D effect. I add freckles to make her seem younger.

2 I paint the clothes, keeping in mind the parts that will be in the shade. The dress is light blue, and the collar, sleeve and skirt borders, and gloves are pink, so I do the shading in purple. Using a similar color for shading adds depth. I paint the apron in gray to make it look stylish. I tone down the brightness of the hues, so even though the picture is colorful it projects a quiet mood.

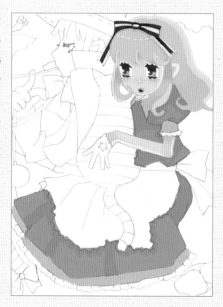

3 Next I paint the boy. I paint his skin a darker shade than the girl's and his eyes purple. I put a hint of pink in the area near the nose to echo the girl's coloring. I paint his hair gray and shade it with wine red, a color similar to that of his silk hat. I paint the pattern on his hat yellow to go with the girl's hair.

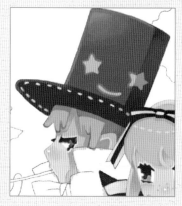

4 I paint the boy's clothes a smart black, because I plan to accent them with some playful, small objects. I add light gray to the parts of his clothes the light shines on. I paint his collar ribbon the same color as the silk hat. To match the main color, black, and the wine red hat, I paint his shirt a reddish brown to which I've added a lot of white. I add white to all of the dark colors of the boy's clothing to give them a soft look.

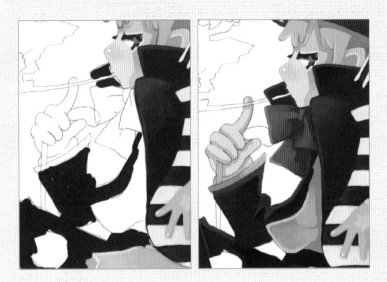

5 I paint his socks black and white, then paint the smaller items. I use bright red to paint the blood dripping from the heart playing card sticking into his knee, because I want to get a symbolic effect. On the other hand, I don't want the pocket watch he's holding to stand out, so I paint it white and purple, and the string the same wine red as his ribbon.

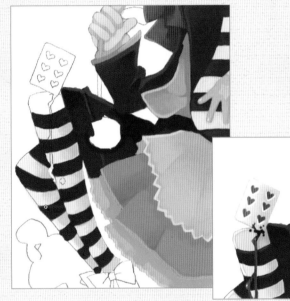

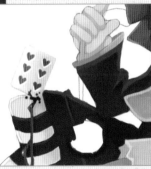

6 I set this picture at night, so I did the mushrooms at their feet in pop colors—orange, green, yellow, and pink with polka dots—to lends sweetness and gaiety.

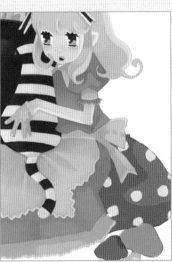

7 I paint the forest in the background in a gradation of dark greens to make it look ominous. To make sure that the characters don't fade into the background, I add white to the dark green color used to paint the boundary line between them and the woods. I want to make the apparition that floats out of the boy's pipe a mysterious figure, so I pose it like this.

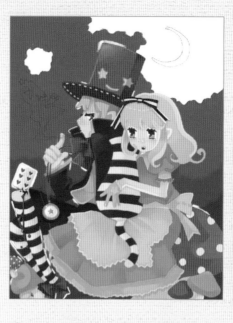

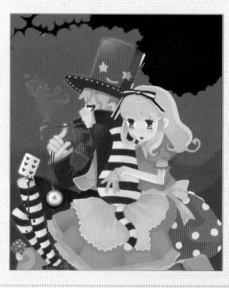

8 I paint the sky black; to get a scary effect, I paint the places where the sky is glimpsed through the trees to look like cuts on the body of the forest. For the moon I choose a darker yellow than the girl's hair, to emphasize its distance and its place in the nocturnal world.

9 I paint in the rays of moonlight to finish the picture. As I add color to each layer, the lines in the drawing gradually disappear. When the picture is finished, all the lines are gone.

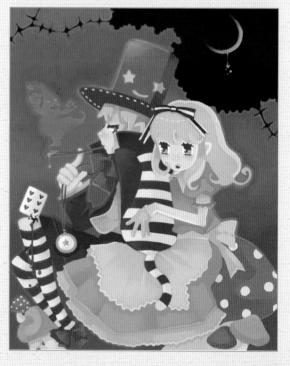

Magic
I had trouble with the girl's facial expression. (p. 97)

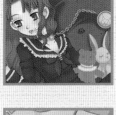

René Magritte Girl
I like her clothes and the pose she's in. (p. 100)

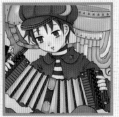

Untitled
This took a lot of time, even without a title. (p. 98)

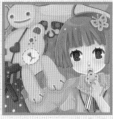

Junk Girl
I like to draw stuffed animals and sweets. (p. 101)

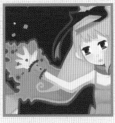

A Girl and the End of the World
Even though she's all alone, she's still having a good time. (p. 99)

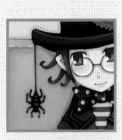

Boy
I enjoyed doing the chair design. (p. 101)

Alice
This has an Alice-in-Wonderland feel. (p. 99)

Xmas
I wanted this to be a stylish illustration. (p. 101)

Goth Sisters
I had fun drawing in the details and painting the clothes. (p. 100)

Magic Shop
I think the overall effect isn't that exciting. (p. 101)

Wizard
I like the color of the sky. (p. 100)

Shigeru Katoh

加藤しげる

Strong lines and fast-paced stories. Shigeru Kato's power to breathe life into characters and create a compelling narrative reaffirms for us the appeal of the expressive form known as manga.

A sequence of pictures arranged to tell a story turns into an alternate reality. Each picture is full of meaning, but you have to read the whole manga to get its message—that's one of the fun things about it. (The story begins on page 111 and reads from right to left in the Japanese style, ending on page 107.) Enjoy!

Personal Data

Birthday:	July 20, 1980
Birthplace:	Tokyo, Japan
Gender:	Female
Education:	High school (design course), left the university before graduation
Working tools;	Hand drawn, mainly acrylic gouache
Favorite artists:	Katsuhiro Otomo, Mike Mignola

Awards and work experience: Tezuka Award, Second Prize for *Boku to Usagi* (Me and the rabbit) (*Weekly Shonen Jump*, a popular Japanese magazine), *Tomato* (*Akamaru Jump*, an extra edition of *Weekly Shonen Jump*), *Akai Daichi ni Umareta Senshi no Hanashi* (The story of a warrior born in the land of red soil) (Winter 2003 issue of the quarterly magazine *S*), *USA BOY!* (*S* Spring 2003), *Jinsei Kaido Hazure Boshi* (The star that got off track on the highway of life) (*S* Summer 2003), *Nirai* (*S* Fall 2003), *Aruji to Soregashi* (The master and Mr. So-and-So) (*S* Winter 2004)

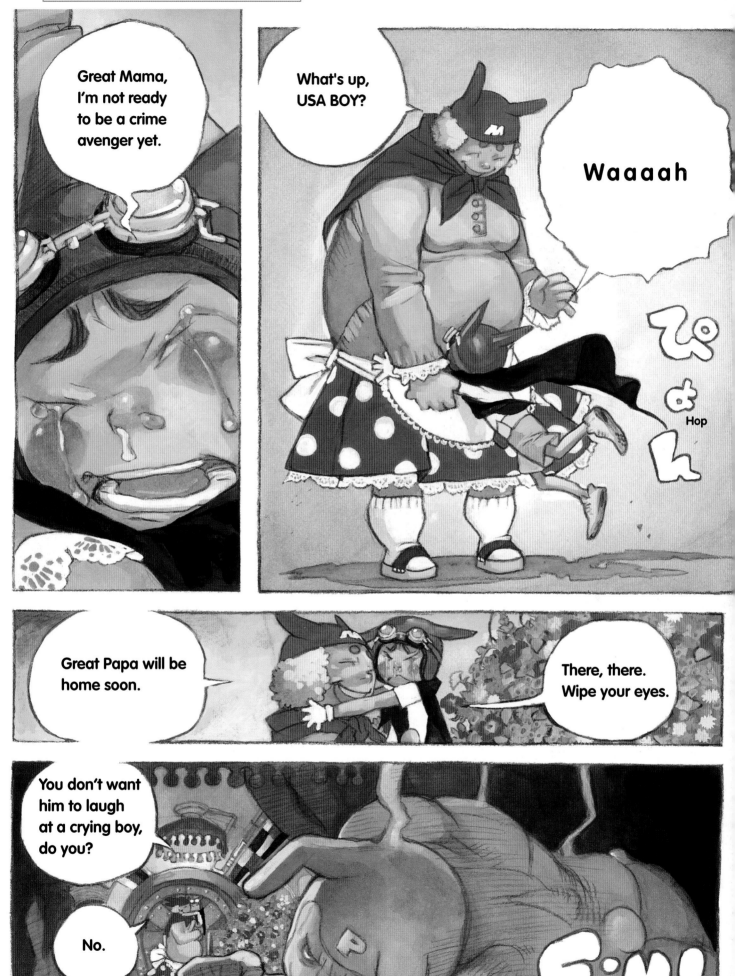

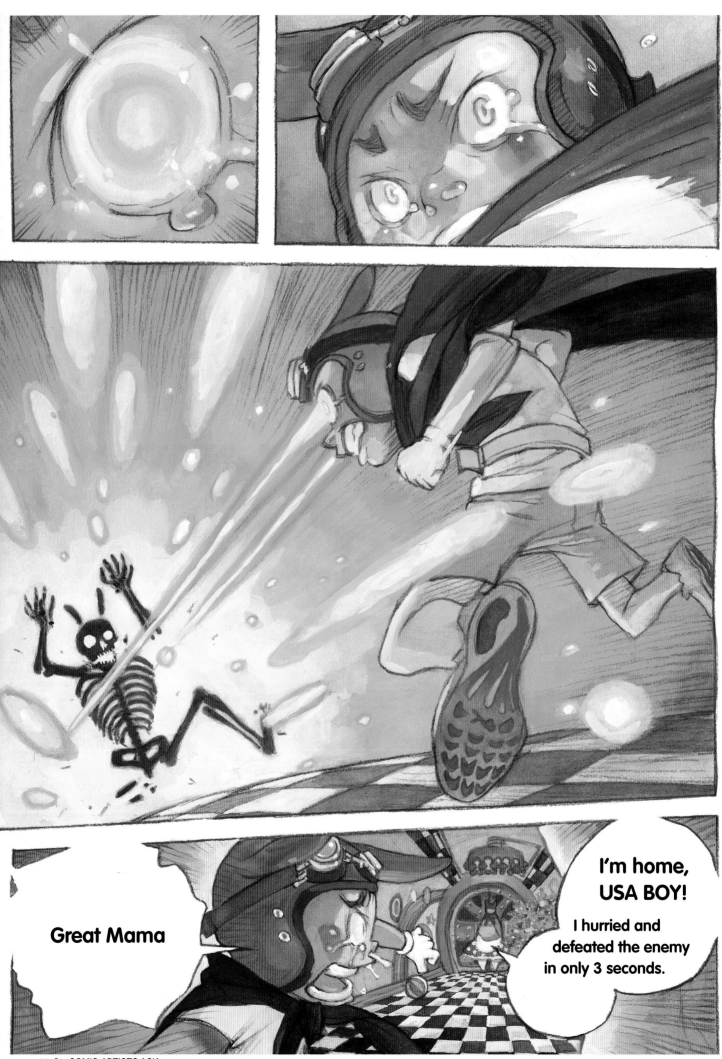

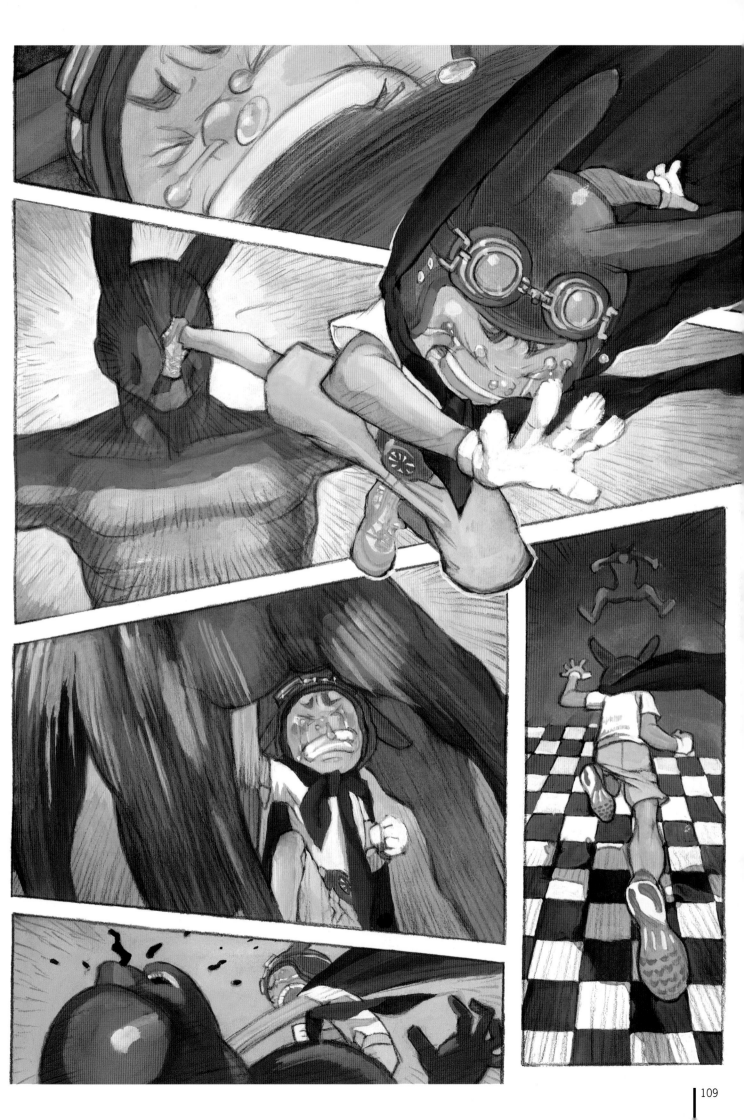

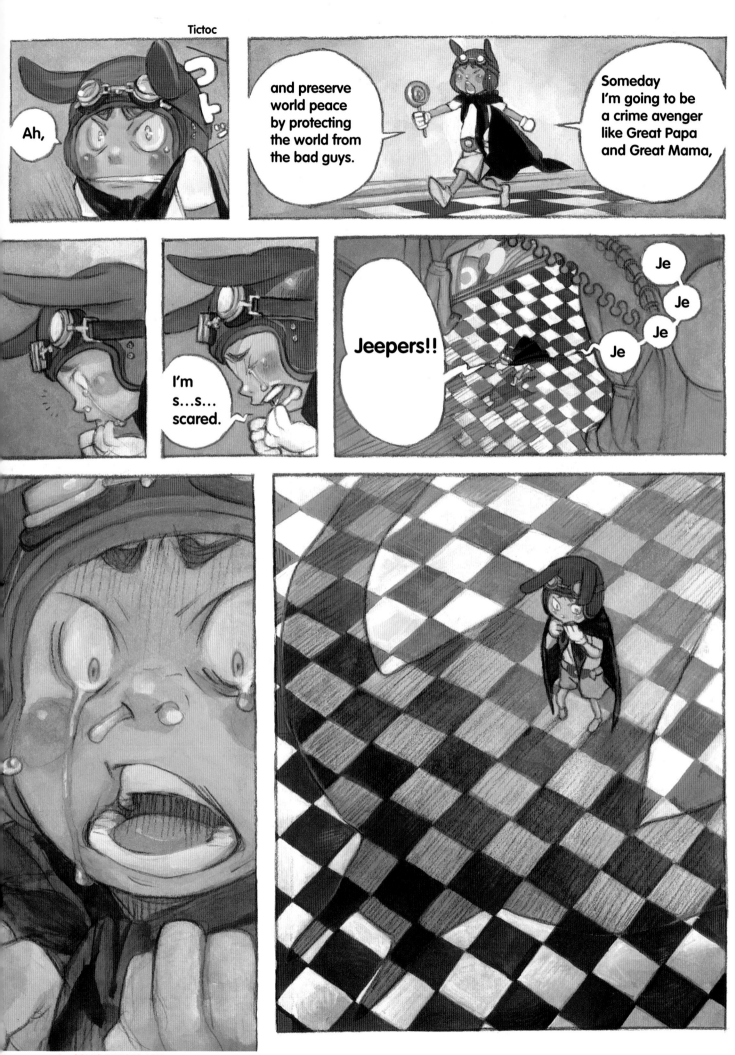

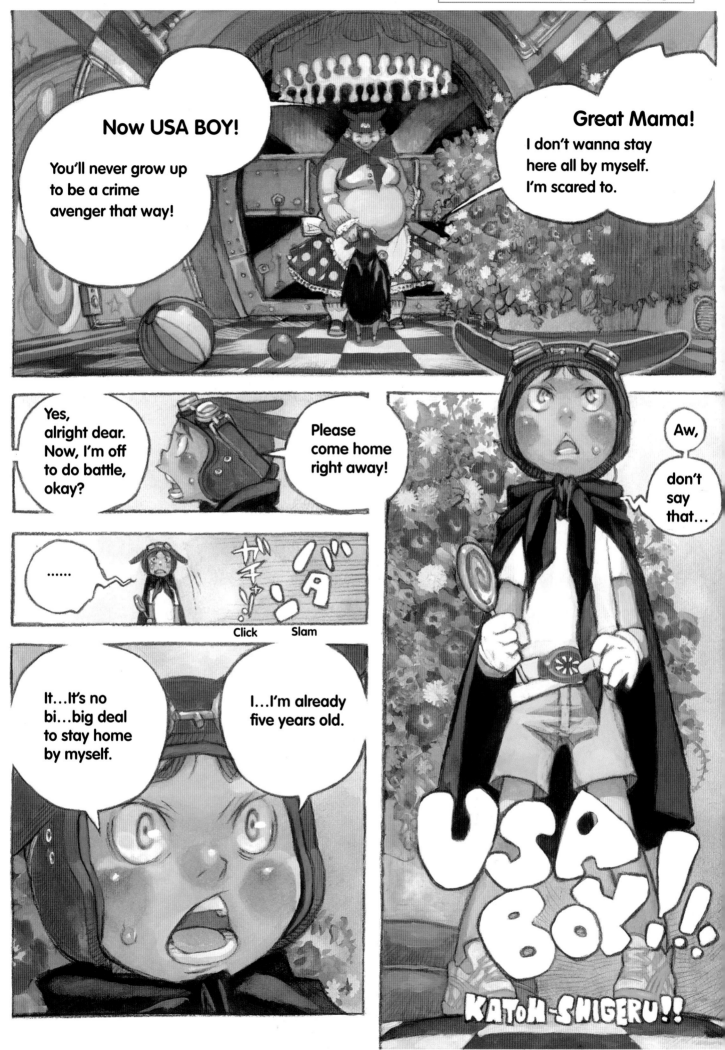

Step by Step

In Japan, the manga process begins with a layout of sketches that shows the story composition. We call it the "name." This is shown to the editor, then necessary adjustments are made to make the story and its highlights more comprehensible to the reader. Here I'll introduce the changes that were made to the layout for USA BOY! up to the completion of the final version.

First draft

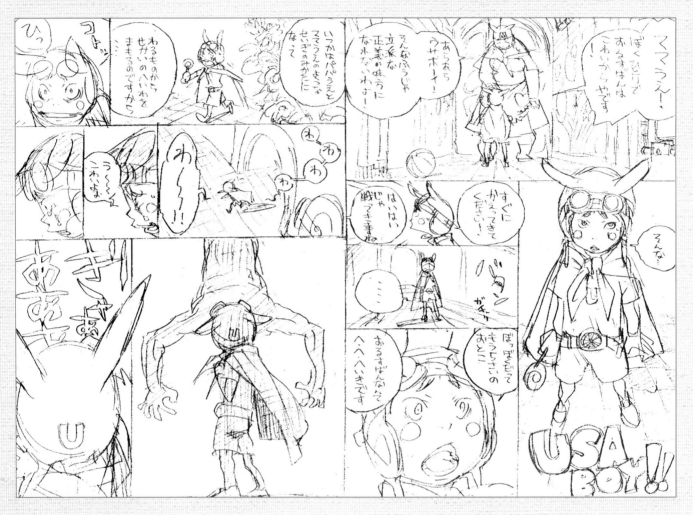

On the first page, USA BOY makes his appearance. I show the basics: USA BOY in contrast to his hefty mother and the decorative objects in the house in order to present him as a very small, timid boy; the colorful, pastel house he lives in; and the fact that he worships heroes. I use the second frame for a full-body picture of USA BOY and the title. The key is to let the reader know that he's the main character. By the way, USA is pronounced "oo (as in "goo") suh." It's used as a pet name for rabbits, which are called usagi in Japanese. There are lots of rabbit characters in Japan and they're usually named Usa-chan and are viewed as adorable.

Second draft

The scene on the second page shows USA BOY alone in his house when someone breaks in. The point here is to show USA BOY's fear. I think up ways to do this. The first version has USA BOY suddenly coming face to face with the intruder, who drops down from the ceiling. The twist is that the intruder is really USA BOY's father, so it wouldn't work for USA BOY to see his face at this point. And the reader wouldn't be able to see the expression of fear on USA BOY's face. I try another approach. The second version has USA BOY noticing a giant shadow. I draw a side view of USA BOY crying and add a sound effect, but decide to redo the drawing. The final version projects USA BOY's fear much better.

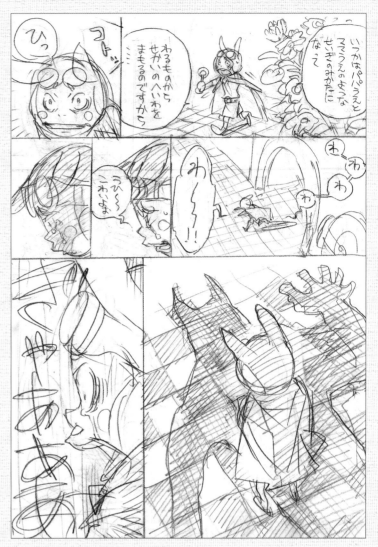

Final Manuscript

In the final version I add perspective and draw the giant shadow even larger. USA BOY's small stature is emphasized in contrast to the spacious interior of the house, and the size of the shadow alludes to the magnitude of his fear. I draw USA BOY full-face, because it is the most direct way to project his emotion to the reader. Given how the story develops on the next page, I dispense with the sound effect and give USA BOY an expression that shows he's on the brink of screaming.

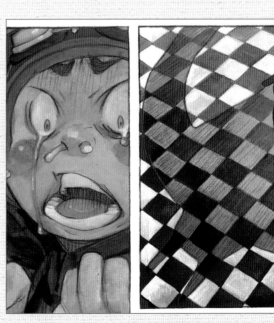

1st Draft

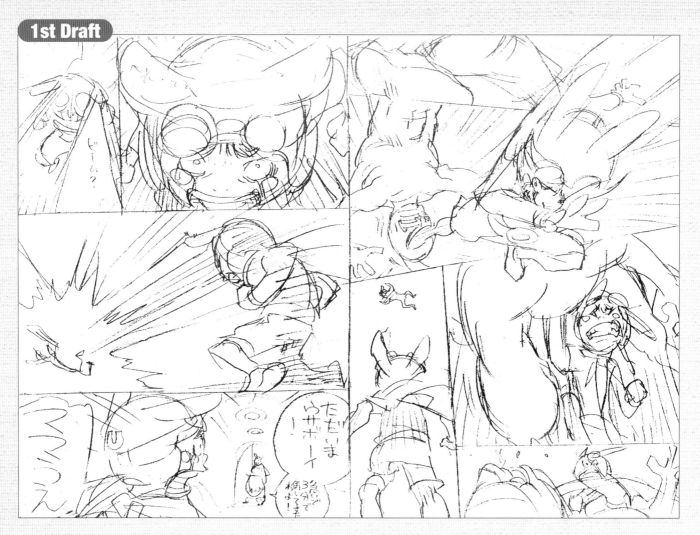

Pages 3 and 4 contain the action. This is an important scene because it shows that, although USA BOY looks like a weakling, he's really very strong. I'm careful not to reveal his father's face to either the reader or to USA BOY. The flow of the action goes like this: USA BOY jumps up and kicks the intruder in the face, delivers a blow to the body, and then lands on the ground and electrocutes him with a beam. In the first frame on the third page of the first draft, I start by drawing his feet jumping. In the second frame, he kicks the intruder dropping upside down from the ceiling. On page 4, I do a close-up of a beam being ejected from the ears on the hat of the inflamed USA BOY. On this page, I start with a close-up and gradually zoom out on successive frames.

Final Manuscript

I redraw the beam so that it comes out of his eyes instead of the hat ears. This action sequence is intended to show that the strong emotion USA BOY's fear generates enables him to carry out a powerful attack. So the beam coming from the eyes fits the story development better than if it comes out of his hat. I give the father's ordeal a comical twist by drawing him as a skeleton when he is electrocuted by the beam.

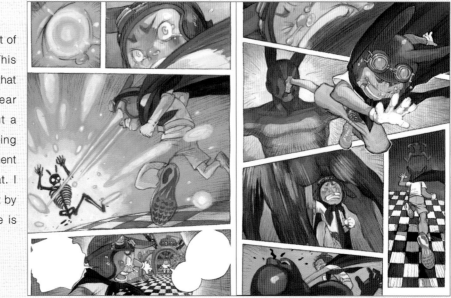

2nd Draft

I change the intruder's expression on the second page. To emphasize the fact that he has not seen the intruder's face, I start by drawing a close-up of USA BOY's face with his eyes closed. Then, to show that his repeated attacks leave him no time to see the intruder's face, I draw a series of pictures that show him rushing at the intruder, delivering a blow to the body, and then slugging him. I slant the frames down the page to convey movement and how quickly his actions take place. By drawing a close-up of the hat ears in the second frame on page 4, I give the reader the impression that something is about to come out of them. The frame in which the beam hits its target is a high point of the story, so I make it larger than the one in the 1st draft.

1st and 2nd Drafts

I make almost no changes on the last page. To emphasize USA BOY's small size, I turn the direction of his mother's body more toward the front and play up her bulk. I also draw the father's face in the last frame so that it's easier to see his expression of mortification. The joke is that the father was only trying to surprise his son, so I furtively write a P (for Great Papa) on his hat to indicate that USA BOY jumped the gun.

Step by Step Coloring

Let me explain a little bit about the coloring for this manga. I do the rough drawings for the "name" on over-the-counter drawing paper. I color in the pictures as I add detail, so at this stage I just do basic coloring. I use acrylic paints. I always cover the frame lines and the speech balloons with masking tape when I color drawings.

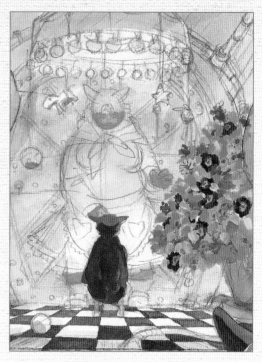

First I paint USA BOY's clothes. Originally I give him striped pants, but repaint them a plain color so they don't clash with all the decorative objects in the house. I draw a rabbit mark on his T-shirt, but decide against it. I change his belt from blue to red. Incidentally, I decorate the belt to resemble the ones we usually see on heroes in Japan.

Next I paint USA BOY's face. The balloons are masked, so I don't need to worry about color running over when I paint the skin. Kids with chubby red cheeks are considered cute, so I give his nose and cheeks a touch of red. But the face color in this drawing is too dark, so I redo it. If you look closely, you'll notice that USA BOY's facial expression and the trim on his hat are different from the way I did them in the final manuscript. I use a lot of colors for this manga and I want to integrate them. It doesn't work well in the first drawing, though, and I end up doing everything over again.

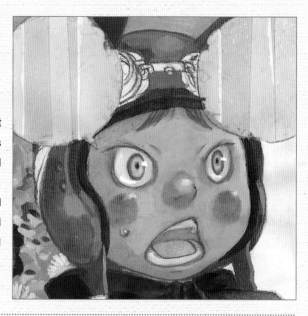

Final Manuscript

I make slight changes to the mother's hand position in the first frame and USA BOY's hand position in the second frame in order to express the characters' feelings more clearly. Here is the completed page, done to look like a colorful, pop art-style child's play area.

HOW I WORK

When I created USA BOY, I took the reader into consideration more than I usually do, as well as the magazine's rough concept of a cute, cartoony character. I used colors that seem to come out of a toy box or a house made of candy in order to give the character a sweet image.

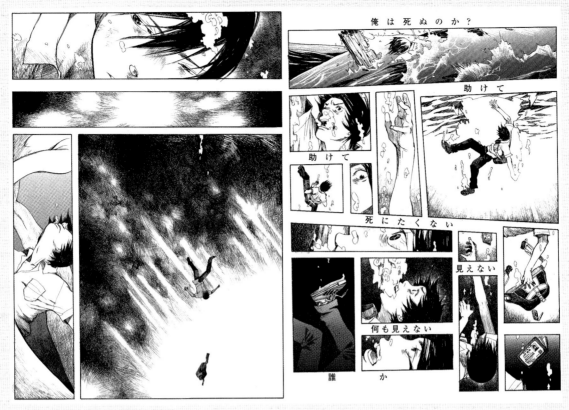

Nirai

This story was done for the summer issue of a magazine. I wanted to do a poetical story set at sea that had a mystical atmosphere, which is a radical departure for me. I spent hours drawing in all the dark spaces, but it was great fun. ("Nirai Kanai" is an Okinawan expression for a paradise beyond the sea where the gods live.)

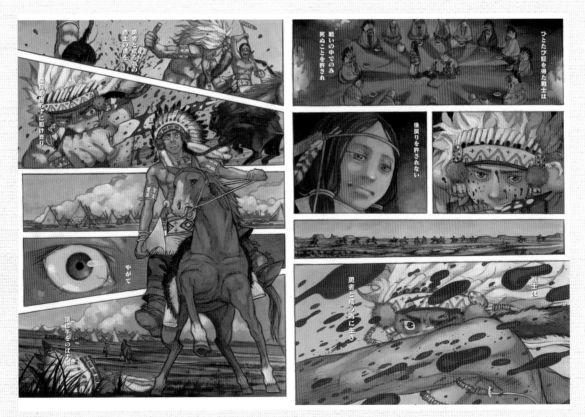

The Story of a Warrior Born in the Land of Red Soil

I wanted to draw a story about a massacre involving Native Americans. I colored this manga with the intention of impressing "red" on the reader's mind. I wish I had had time to do more research on the subject! This is a theme I'm going to try again.

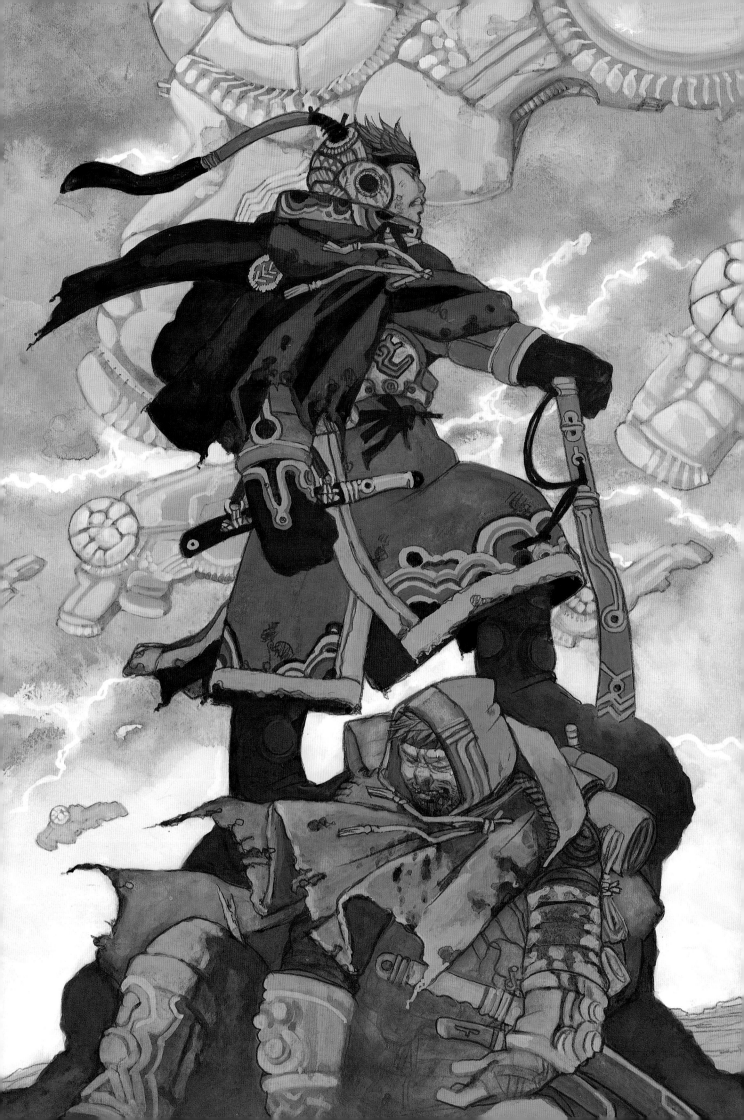

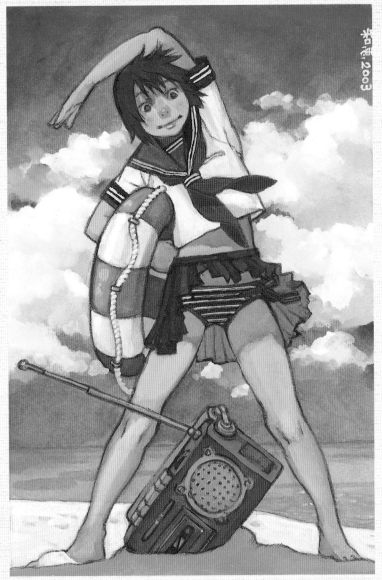

A Girl at the Seaside
Originally, I painted this image with the idea that it would appear on a postcard I'd sell. In the end, though, it wasn't part of the sale.

Horse
This was painted about three years ago for a New Year's card. I used computer graphics to color the image.

Untitled
I created this image especially for this book. Actually, I don't usually do work like this because I am not an illustrator. I would like to say "thank you" for giving me this opportunity; I learned a lot while doing this picture.

Sources of Inspiration

Index of Names

A

Akagawa, Jiro (Japan)
Novelist
Tortoiseshell Cat Holmes series, San Shimai (Three sisters) series

Arakawa, Hiromu (Japan)
Manga artist
Fullmetal Alchemist

Araki, Hirohiko (Japan)
Manga artist
Jojo's Bizarre Adventures, *Mashonen BT* (Magic boy BT), *Baoh the Visitor*

Akamatsu, Ken (Japan)
Manga artist
Love Hina, *Ai ga Tomaranai* (Endless love), *Magister Negi Magi!*

Akatsuki, Gomoku (Japan)
Illustrator, character designer
Taisen Mah-jongg Final Romance 4 (Mah-jongg match: Final Romance 4), *Gunbarich*, *Mania King*

Amano, Yoshitaka (Japan)
Illustrator, artist
Yattaman, *Gatchaman* (for Tatsunoko Production), *Final Fantasy* (game), *Vampire Hunter D*, *Guin Saga* (novels)

Antonioni, Michelangelo (Italy)
Filmmaker
The Eclipse, Blow-Up, The Red Desert

B

Beksinski, Zdzislaw (Poland)
Artist
The Fantastic Art of Beksinski

C

Calvino, Italo (Italy)
Novelist
The Baron in the Trees, t zero (aka Time and the Hunter)

Choi, Ho-Chol (Korea)
Euljiro Junkansen (Euljiro loopline) (manga book)

CLAMP (Japan)
Manga artist
X, Cardcaptor Sakura, Chobits, Tokyo Babylon

Cohen, Leonard (Canada)
Musician, poet
"Suzanne" (song title)

Craft Ebbing & Co. (Japan)
Creator
Dokoka ni Itte Shimatta Monotachi (The one's who went somewhere), *Cloud Collector, The Dictionary of Azoth*

Crumb, Robert (United States)
Comic artist, illustrator, musician
Fritz the Cat, Mister Natural, Keep On Truckin'

E

Ende, Michael (Germany)
Author of children's literature
Momo, The Neverending Story

Endo, Hiroki (Japan)
Manga artist
Eden: It's an Endless World!, *Endo Hiroki Tanpen-Shu* (Hiroki Endo: Manga collection)

F

Fellini, Federico (Italy)
Filmmaker
La Strada, 8 ½, Nights of Cabiria

Frazetta, Frank (United States)
Manga artist, illustrator
Cover illustrations for science fiction writer Edgar Rice Burroughs' Mars series and *At the Earth's Core* series

Funato, Akari (Japan)
Manga artist, illustrator
Wakakusa Ikka de Ikou (Let's go, little women), *Lunar, Under the Rose, illustrations for the Ryuketsu Megami-Den* (Legend of the bloody goddess) series and *Rio no Kagaku Sosa File* (Rio's scientific criminal investigation files) series (novels)

Fujiwara, Kamui (Japan)
Manga artist
Raika, Fukujin-cho Kitan (The strange story of Fukujin-cho), *Dragon Quest Retsuden: Roto no Monsho* (Dragon Quest: The crest of Roto)

Furuya, Minoru (Japan)
Manga artist
Ike! Inachu Takkyubu (Let's go, Ina Junior High ping pong club), *Boku to Issho* (With me), *Himizu, Green Hill*

G

Gonzo (Japan)
Animation studio
Blue Submarine No. 6, Last Exile, Vandread, Fairy Air Force, Final Fantasy: Unlimited

Gorey, Edward (United States)
Illustrator, author, playwright
The Doubtful Guest, The Gashlycrumb Tinies, The Epiplectic Bicycle

H

Haas, Irene (United States)
Picture book illustrator
The Maggie B, A Summertime Song, Little Moon Theater

Harada, Takehito (Japan)
Illustrator
Daburuburitto (novel), *Disgaea, Phantom Brave* (games)

Hirasawa, Susumu (Japan)
Musician
Music for Berserk, Millenium Actress (anime)

Hockney, David (Great Britain)
Artist
Britain's leading pop artist. He now lives and works in Los Angeles.

Hojo, Tsukasa (Japan)
Manga artist
Angel Heart, City Hunter, Cat's Eye, F. Compo

I

Inoue, Naohisa (Japan)
Illustrator
Art creator for the tale of "The Story Baron Gave Me" from *Whisper of the Heart, Iblard no Tabi* (Journey to Iblard), *Iblard Hakubutsushi* (Iblard natural history magazine), *Gardens of the Sky, Stars of the Sea*

Ishinomori, Shotaro (Japan)
Manga artist
Cyborg 009, Kamen Rider (Masked rider), *Hotel, Sabu to Ichi Torimono Hikae* (Sabu and Ichi's detective story)

Iwahara, Yuji (Japan)
Manga artist
Chikyu Misaki (Earth Misaki), *Koudelka, King of Ibara, Okami no Hitomi* (Wolf's eyes). *Kishin Doji Zenki FX, Bomberman '94* (Hudson Soft games)

J

Jarman, Derek (Great Britain)
Artist, filmmaker
Wittgenstein, Edward II, Caravaggio

K

Kadono, Kouhei (Japan)
Novelist
Boogiepop Phantom, *A Case of Dragonslayer*

Kaneko, Shinya (Japan)
Manga artist
Culdcept, Illust Garage (collection of illustrations)

Kanno, Yoko (Japan)
Composer
Cowboy Bebop, ∀*Gundam*, *Escaflowne*

Kikuchi, Hideyuki (Japan)
Novelist
Vampire Hunter D, *Mao Den* (Demon saga)

Kishiro, Yukito (Japan)
Manga artist
Gunnm (aka Battle Angel Alita), *Haisha* (aka Ashen Victor), *Aqua Knight*

Kuroboshi, Kouhaku (Japan)
Illustrator, character designer
Kino's Journey, the Beautiful World, *Summon Night* (game)

Kusanagi, Takuhito (Japan)
Illustrator, manga artist
Shang-Hai Kaijinzoku (manga), *Grandia* (game)

M

Maejima, Shigeki (Japan)
Illustrator
Bright Lights Holy Land, *Tatsumori Ke no Shokutaku* (Dining at the Tatsumori's house) (novels), *The Seed* (game)

Makihara, Noriyuki (Japan)
Musician
"Donna Toki Mo" (Anytime), "Spy", "Do Shiyo mo Nai Boku ni Tenshi ga Orite Kita" (An angel came down from heaven to hopeless me)

Masamune, Shirow (Japan)
Manga artist
Kokakukidotai (GHOST IN THE SHELL), *Appleseed*

Mattotti, Lorenzo (Italy)
Illustrator, bande dessinée artist
Tram Tram Rock, *Caboto* (comics), illustrations for *Eugenio*, *Pinocchio* (children's books)

McCaffrey, Anne (United States)
Novelist
Pern series, *The Ship Who Sang* series

Mignola, Mike (United States)
Hellboy, *Batman/Hellboy/Starman*

Miura, Kentaro (Japan)
Manga illustrator
Berserk, *Japan*, *Oro Den* (Legend of the wolf king)

Miyashita, Akira (Japan)
Manga artist
Sakigake! Otoko Juku (Head start! Bad boys cram school), *Ten Yori Takaku* (Higher than heaven), *Bakudan* (Bomb), *Geki!! Gokudora Ikka* (The fierce gokudora family)

Miyazaki, Hayao (Japan)
Anime director, manga artist
Nausicaä of the Valley of Wind; *Laputa, Castle in the Sky*; *The Princess Mononoke*, *Spirited Away*

Morimoto, Koji (Japan)
Anime director
The Animatrix: Beyond, *Noiseman Sound Insect*, *Extra* (music clip)

Mucha, Alphonse (Czechoslovakia)
Artist
Gismonda and other revolutionary artwork in a style that came to be known as "le style Mucha." Instrumental in shaping the French Art Nouveau movement.

Murata, Range (Japan)
Illustrator, character designer
Goketsuji Ichizoku (The Goketsu Temple clan)
(game), *Last Exile* (anime)

N

Nagano, Mamoru (Japan)
Manga artist
Tales of Joker, *The Five Star Stories*

Ningen Isu (Japan)
Musician
Ningen Isu (Human chair), *Sakura no Mori no Mankai no Shita* (Under the cherry blossoms in full bloom in the cherry tree forest), album of songs based on *Mugen no Junin* (Endless dweller)

Nishieda (Japan)
Illustrator
Plenty of Pretty Sisters (anime), *Daddyface Medusa*

Nishimura, Kinu (Japan)
Character designer (Capcom)
Street Fighter (game), *Over Man King Gainer* (anime)

Nishioka kyoudai (brother and sister) (Japan)
Manga artists
Mari no Issho (Mari's life), *Jigoku* (Hell), *Kokoro no Kanashimi* (Lament of the heart), *Hitogoroshi no Onnanoko no Hanashi* (The story of a girl murderer)

O

Ogata, Takeshi (Japan)
Illustrator
Boogiepop Phantom, *Doll*, *Boogiepop and Others*

Ogura, Hiromasa (Japan)
Animation art director
Ghost in the Shell, *Last Exile*, *Mobile Police Patlabor*

OKAMA (Japan)
Manga artist, illustrator
Megurikuru Haru (Spring's return), *School*, *Cat's World*, *Hanafuda*, *Okamax* (collection of illustrations)

Ono, Fuyumi (Japan)
Novelist
The Twelve Kingdoms, *Shiki* (Demon corpse)

Oshii, Mamoru (Japan)
Anime director
Mobile Police Patlabor, *Ghost in the Shell*, *Avalon*

Otomo, Katsuhiro (Japan)
Manga artist, anime director
Akira, *Domu: A Child's Dream*, *Roujin Z* (Old man Z), *Memories*

P

Production IG (Japan)
Animation studio
Ghost in the Shell, *Mobile Police Patlabor*, *Jin-Roh*, *Sakura Wars The Movie*

R

Rembrandt (Netherlands)
Artist
The Night Watch, *Man in a Gold Helmet*

S

Sadamoto, Yoshiyuki (Japan)
Character designer, manga artist
Neon Genesis Evangelion (character design and manga illustration), *The Secret of Blue Water* (aka Nadia of the Mysterious Seas) (anime)

Samura, Hiroaki (Japan)
Manga artist
Mugen no Junin (Endless dweller), *Ohikkoshi* (Moving)

Sashida, Minoru (Japan)
Designer (Namco)
Techno Drive, *Ace Combat 3*, *Mr. Driller*

Shio (Japan)
Designer (Konami)
Pop'n Music series

Shinkai, Makoto (Japan)
Anime creator
Voices of a Distant Star, She and Her Cat, Other Worlds, Enclosed World

Shinofusa, Rokuro (Japan)
Manga Artist
Kudanshi, Kaseifu ga Mokusatsu (The housemaid was silent)

Studio 4°C (Japan)
Animation studio
The Animatrix: Beyond, Memories, Spriggan, Princess Arite

Studio Ghibli (Japan)
Animation studio
Nausicaä of the Valley of Wind; Laputa, Castle in the Sky; My Neighbor Totoro, The Princess Mononoke, Spirited Away

Suga, Shikao (Japan)
Musician
"Yoake Mae" (Before dawn), "Yozora no Muko" (Beyond the night sky) (The latter song is sung in junior high school music classes and appears in music textbooks.)

Sugawara, Kuniyuki (Japan)
Manga artist
Majyutsukko! Kaido-kun! (Witchcraft kid Kaido), *Oresama! Gyanizu!!*

T

Takamichi (Japan)
Illustrator, character designer
Hoshigami (game), Takamichi Art Works

Tagro (Japan)
Manga artist
Uchu Chintai Sarugasso (The Saruga apartments in outer space), *Mafia to Rua* (The mafia and Rua),

Roku-nen Ichi-kumi (6th grade, class 1), *Live Well*

Takano, Aya (Japan)
Illustrator
Hot Banana Fudge, Space Ship ε ε

Takeuchi, Sakura (Japan)
Manga artist
My Dear Marie, Tokumei Kokosei (High school student on special appointment)

Takeya, Takayuki (Japan)
Sculptor
Prototypes for garage kits for *Gamera 3, Jinzo Ningen Hakaida* (Artifical human Hakaida), *Kamen Rider* (Masked rider). *Ryoshi no Kakudo* (From the fisherman's angle) (collection of artworks)

Takuma, Tomomasa (Japan)
Manga artist
Tetsu Communication (Railway communication), *Train+Train*

Tanaka, Kunihiko (Japan)
Illustrator, character designer
Xenogears, Xenosaga (games), *Ruin Explorer Fam & Ihrlie* (anime)

Tanaka, Tatsuyuki (Japan)
Animator, manga artist
Akira, The Secret of Blue Water (aka Nadia of the Mysterious Seas), *The Hakkenden, Noiseman Sound Insect, Popolocrois* (anime), *Linda³* (game)

Terada, Katsuya (Japan)
Illustrator, manga artist
Saiyuki Den: Dai En O (The legend of saiyuki: The great ape king), *Rakuda ga Warau* (The camel laughs), *Terada Katsuya Zenbu* (The complete Katsuya Terada) (collection of illustrations), *Virtua Fighter, Tantei Jinguji Saburo* (Detective Saburo Jinguji) (games)

Terasawa, Buichi (Japan)
Manga artist
Cobrea, *Takeru: Supplementary Biography of Japan*, *Midnight Eye Goku*

Tezuka, Osamu (Japan)
Manga artist
The father of Japanese manga. *Mighty Atom*, *Black Jack*, *Phoenix*, *Princess Knight*, *The Three Adolphs*

Tokusatsu (Japan)
4-member rock band led by Kenji Otsuki, who was formerly a member of Kinniku Shojo Tai. Bakutan (Bomb), Nuigulumar, Agitator

U

Uemura, Shoen (Japan)
Artist
First woman recipient of the Order of Culture (1948). *Hanazakari* (In full bloom), *Gesshoku no Yoi* (Night of the eclipse), *Tsuzumi no Oto* (Sound of the hand drum)

Urasawa, Naoki (Japan)
Manga artist
Monster, *20th Century Boys*, *Yawara!*

V

Van Allsburg, Chris (United States)
Picture book illustrator
Jumanji, *The Widow's Broom*, *The Polar Express*

W

Wood, Ashley (Australia)
Artist
Popbot, *Lore* (manga series), *Uno Fanta: The Art of Ashley Wood*

Y

Yamada, Akihiro (Japan)
Manga artist, illustrator, character designer
The Chronicles of Stargazer, *Beast of East*, *Record of Lodoss War: The Lady of Pharis*, *The Twelve*

Kingdoms (novel), *Mystic Ark* (game), *Rahxephon* (anime)

Yamagishi, Ryoko (Japan)
Manga artist
Arabesque, *Hi Izurutokoro no Tenshi* (Prince of Japan), *Yousei O* (Fairy king), *Mai Hime: Terepushikora* (Dancing princess: Terpsichore)

Yang, Kyung-il (Korea)
Manga Artist
Island, *Zombie Hunter*

Yoshida, Akihiko (Japan)
Game graphics designer (Square Enix)
Ogre Battle Saga, *Tactics Ogre*, *Vagrant Story*, *Final Fantasy Tactics*

Credits

Kumiko

p. 11: Illustration for *Newmint*, *Comikers*, Winter 2002 issue (Bijutsu Shuppan-Sha, Ltd.)

p. 12: New illustration

p. 13: (Top) Illustration for *Gallery S*, Magazine *S*, Winter 2004 issue (Style Co., Ltd.)

p. 15: (Bottom) Illustration for *Poetry and Märchen*, May 2003 issue (SANRIO Co., Ltd.)

Other illustrations are unreleased.

joshclub

p. 18 – 23: Illustrations from the artist's Web site.

Imperial boy

p. 27: Ilustration for *Sparkle*, Magazine *S*, Autumn 2003 issue (Style Co., Ltd.)

Other illustrations are from the artist's Web site.

Ryusuke Hamamoto

p. 38: New illustration

p. 39: Cover illustration for the interactive comic *Welcome to White Chaos!*

p. 40: New illustration

p. 44: New illustration

Other illustrations are from the artist's Web site.

maxx

p. 47: Illustration from the artist's Web site, © 2004 Maxx Studio

p. 48 – 50: *Soulless* character design, © 2003 Sonnori Co., Ltd.

p. 51: (Top left) Poster for the online game *Matin 2*, © 2003 YMIR ENTERTAINMENT

p. 51: (Top right) Poster for the online game *Forgotten Saga 2*, © 2003 Wizard Soft, Sonnori Co., Ltd.

p. 51: (Bottom) Illustration from the artist's Web site, © 2004 Maxx Studio

p. 52 – 53: (Top) Sketch, © 2003 Maxx Studio

p. 52 – 53: (Bottom) Sketch, © 2003 Sonnori Co., Ltd.

Other illustrations are from the artist's web site.

OPON

p. 55: Pinup illustration for *Magi-Cu Premium*, May 2003 (Enterbrain Inc.)

p. 56 – 57: Illustration for the MMORPG *Tales Weaver*

p. 58 – 59: Illustration and character design for the FPS game *Archshade*

p. 60 – 61: (Top) Character design for the FPS game *Archshade*

Other illustrations are original for this book.

Craig Au Yeung

p. 63: Poster for a comix exhibition by the artist in February 2003

p. 64 – 65: Poster for the summer 2003 newsletter of a Hong Kong design school

p. 66 – 67: Excerpt from the comix series *Out There*

NYORO

p. 72: Ilustration for the *Illust-Masters*, *Comikers*, Spring 2002 issue (Bijutsu Shuppan-Sha, Ltd.)

p. 73: (Top) Illustration for the *Illust-Masters*, *Comikers*, Autumn 2001 issue (Bijutsu Shuppan-Sha, Ltd.)

p. 73: (Bottom left) Illustration for Sparkle, Magazine *S*, Spring 2003 issue (Style Co., Ltd.)

p. 73: (Bottom right) Illustration for the *Illust-Masters*, *Comikers*, Winter 2002 issue (*Bijutsu Shuppan-Sha, Ltd.*)

p. 74: Illustration for the *Illust-Masters*, *Comikers*, Summer 2001 issue (Bijutsu Shuppan-Sha, Ltd.)

p. 78: New illustration

Other illustrations are from the artist's Web site.

Kon-Shu

p. 80 – 85: Illustrations from the artist's Web site.

D.K

p. 90: Illustration for the manga collection error, Comikers Spring 2001 issue, Vol.1 (Bijutsu Shuppan-Sha, Ltd.)

p. 94 – 95: (Top) Mecha design for the movie *Casshern*

Other illustrations are from the artist's web site.

AYARA

p. 97: Illustration for *Gallery S*, Magazine *S*, Autumn 2003 issue (Style Co., Ltd.)

p. 98: Illustration for *Gallery S*, Magazine *S*, Spring 2003 issue (Style Co., Ltd.)

p. 99: (Bottom) New illustration

Other illustrations are from the artist's Web site.

Shigeru Katoh

p. 107 – 111: Manga for Magazine *S*, Spring 2003 issue (Style Co., Ltd.)

p. 117: (Top) Manga for Magazine *S*, Autumn 2003 issue (Style Co., Ltd.)

p. 117: (Bottom) Manga for Magazine *S*, Winter 2003 issue (Style Co., Ltd.)

p. 118: New illustration

Other illustrations are unreleased

Hirofumi Fujiko

p. 1, 9, 127, 128: New illustrations